Jackson Pollock

Jackson

Yale UNIVERSITY PRESS

NEW HAVEN & LONDON

Pollock

Evelyn Toynton

Set in Janson type by Integrated Publishing Solutions.
Printed in the United States of America.

Library of Congress Cataloging-in-Publication Data

Toynton, Evelyn, 1950–.
Jackson Pollock / Evelyn Toynton.
p. cm.—(Icons of America)
Includes bibliographical references and index.

ISBN 978-0-300-16325-4 (cloth : alk. paper) 1. Pollock, Jackson, 1912–1956—Criticism and interpretation. 2. Art and society—United States—History—20th century. I. Title.
N6537.P57 T69 2012
759.13—dc22
[B]
2011020807

A catalogue record for this book is available from the British Library.

This paper meets the requirements of ANSI/NISO Z39.48–1992 (Permanence of Paper).

10 9 8 7 6 5 4 3 2 1

Icons of America

Mark Crispin Miller, *Series Editor*

Icons of America is a series of short works written by leading scholars, critics, and writers, each of whom tells a new and innovative story about American history and culture through the lens of a single iconic individual, event, object, or cultural phenomenon.

For N

And all who heard should see them there,
And all should cry, Beware! Beware!
His flashing eyes, his floating hair!
Weave a circle round him thrice,
And close your eyes with holy dread,
For he on honey-dew hath fed,
And drunk the milk of Paradise.

—Samuel Taylor Coleridge, "Kubla Khan"

It may be that you do not like his art, but you can hardly refuse it the
tribute of your interest. He disturbs and arrests. . . . The most
insignificant of [his] works suggests a personality which is strange,
tormented, and complex; and it is this surely which prevents even those
who do not like his pictures from being indifferent to them.

—W. Somerset Maugham, *The Moon and Sixpence*

The pure products of America
go crazy

—William Carlos Williams, "To Elsie"

Contents

Contents

Introduction

In October 1948, the photojournalism magazine *Life* featured a roundtable discussion in which an international panel of figures from the world of culture was asked to give its views on whether "modern art, considered as a whole, [was] a good or bad development."[1] *Life*, at that time the leading weekly in the United States, was conservative in its politics and much concerned with issues of morality. Its implicit disapproval of modern art was based on a belief that the work of contemporary painters was divorced from any moral purpose, "with no ethical or theological references." The terms of the debate echoed the controversy in England in the last years of the Victorian era, another age of morality, when figures like Oscar Wilde and the "Frenchified" poets known as the Decadents outraged the general public by spurning the idea that art must provide uplift and instruction. Instead, they espoused the creed known as art for art's sake (*l'art pour l'art*)—a "theology" of art that removes it from the realm of ordinary morality and claims allegiance to beauty alone.

Clement Greenberg, the art critic for the *Nation* and Jackson Pollock's greatest champion, was on the *Life* panel, and Pollock's highly abstract painting *Cathedral* was one of the "extremist" works that the members were asked to consider, and that was reproduced in color in the magazine. Somber in coloring, largely white and black and metallic gray, with very thin sparse lines in orange and yellow flashing upward here and there, and the black paint looping along its surface like coils of delicate barbed wire, it has an almost chilling Gothic quality that makes its name appropriate. Greenberg extolled it as "one of the best paintings recently produced in this country," while such notables as the writer Aldous Huxley and the director of London's Victoria and Albert Museum remained unconvinced. Said Huxley, "It seems to me like a panel for a wallpaper which is repeated indefinitely around the wall." A professor of philosophy remarked that it would make "a pleasant design for a necktie." None of the experts, however, explicitly condemned the painting as immoral or decadent.

Despite the skepticism of the panel, four months later *Life* sent the photographer Arnold Newman to Pollock's studio, and the shots Newman came back with convinced them to go ahead with an article they had been considering. Pollock himself, though he had his doubts, decided to go ahead with it too. In July, he and his wife, Lee Krasner, dressed in their most respectable clothes, presented themselves at *Life's* offices in New York, where they were jointly interviewed, with Krasner amplifying and clarifying Pollock's responses.

In August 1949, *Life's* five million readers were confronted with a two-and-a-half-page spread, in both black-and-white and color, under a headline that turned a statement Greenberg had made about Pollock into a deliberately provocative question: "Is he the greatest living painter in the United States?"[2]

Life received over five hundred letters in response to the piece,

more than any other article they had run all year. Having invited people, in what may have been a spirit of mischief, to answer the question of Pollock's greatness for themselves, the magazine's in-house skeptics were probably not displeased with the furious reaction they got. Most of their readers expressed indignation at the notion that this artist who "drooled" paint, whose work consisted of whorls and skeins of paint flung, dripped, and sometimes spread with sticks across the canvas, could be producing anything more aesthetically valid than a child's finger painting or the splattered drop cloths that were the residue of their own home improvement projects. Nor had the *Life* article been aimed at fending off such comments. Though the editors did not come out and say what they thought of Pollock's work themselves, or of Greenberg's claims for it, the tone of the piece was fairly tongue-in-cheek.

Yet the fact remained that by featuring Pollock in its pages, *Life* was at least acknowledging the possibility that his paintings, and Greenberg's claims for them, were somehow significant. That was an extraordinary development in itself. And if *Life* failed to make a connection between the vast canvases on show and the stirring call to "create the first great American Century" that the magazine's publisher, Henry Luce, had issued in a 1941 editorial, there were others who were beginning to recognize that Pollock's "all-over" works were reflections of the vitality, the vast spaces, and the sense of infinite possibility unique to the American experience.[3] "No limits, just edges," he said of them, a triumphantly American credo.

Before Pollock's breakthrough, American art was generally regarded, both in the United States and abroad, as, at best, a dim second cousin to the great art of Europe. ("The only works of art America has given are her plumbing and her bridges," according to Marcel Duchamp.)[4] When not simply a variation on some form of European art, it was distinctively American mostly by virtue of its subject matter.

In the early thirties Pollock himself, under the influence of his teacher and mentor Thomas Hart Benton, had produced paintings of square dancers and brawny laborers and covered wagons. But the style of these paintings, like Benton's own, was essentially derived from the Mannerism of the European Baroque. For all its ruggedness, its rather aggressive virility, Benton's work, and Pollock's under his tutelage, owed its technique to the Old Masters. The paintings of Pollock's that appeared in *Life*, and the paintings he was to do in the following four years, were American in a very different way. Painted not on the easel, not on the wall, but on the floor, like the Navajo sand paintings that Pollock had seen in his boyhood in the Southwest, they allowed for a whole new kind of freedom: the freedom to move around the painting as he worked—to be, as Pollock said, *in* the painting. They also represented a liberation from the last vestiges of European formalism.

Luce's Messianic rallying cry to his fellow citizens called on all of them, "each to his own measure of capacity, and each in the widest horizon of his vision, to create the first great American Century."[5] Strange as it would undoubtedly have seemed to Henry Luce, and uncomfortable though Pollock would have been with such rhetoric, in his own way he had been answering the call.

* * *

It wasn't his paintings alone, however, that *Life* made famous. Pollock, as would be demonstrated over and over in the next few years, was spectacularly photogenic. The *Life* article showed him leaning up in front of one of his paintings in jeans and a denim jacket, ankles crossed, arms crossed, cigarette dangling from his mouth; both the cocky pose he adopts and the expression on his face convey his defiance, his refusal to cozy up to the camera. He does not look like a civilized man; he looks dangerous and sexy, full

of latent power: a cowboy, or a motorcycle hoodlum. His fellow painter Willem de Kooning gibed that Pollock looked like "some guy who works at the service station pumping gas."[6] But that was precisely the point. The very fact that his paintings had been made not with gentlemanly oils but with the sort of industrial paints used by builders and laborers was further proof of his tough-guy status. This was no effete character in a smock and a beret; this was a portrait of the artist as America—and the rest of the world—had never seen him before.

The brooding rebelliousness of the *Life* photograph prefigured the screen personas who were to burst into the national consciousness a few years later, actors like Marlon Brando and James Dean, down and dirty American existentialists. (In fact, there are those who claim that Pollock was one of the models for Stanley Kowalski, the antihero of *A Streetcar Named Desire* and the role that first made Brando famous: a few years before Tennessee Williams wrote the play, he became acquainted with Pollock and observed his explosive behavior.) Above all, they were hailed as *authentic*, a quality seen as terribly important, and in increasingly short supply, in that time and place. It was not only J. D. Salinger's Holden Caulfield who, on his appearance in the pages of *The Catcher in the Rye* in 1951, railed against phonies. There was a pervasive fear that some particularly American brand of honesty and integrity and independence of spirit was being lost for good.

But the sort of macho these new heroes represented was not of the old, self-assured kind, personified for an earlier generation by such figures as Gary Cooper and Spencer Tracy. Wounded as well as alienated, they were not confidently manly figures, in control of their destinies, but raging, conflicted ones—as though in recognition that the age would not allow for control; that the forces lined up against the individual were too great, too complex, for him to master.

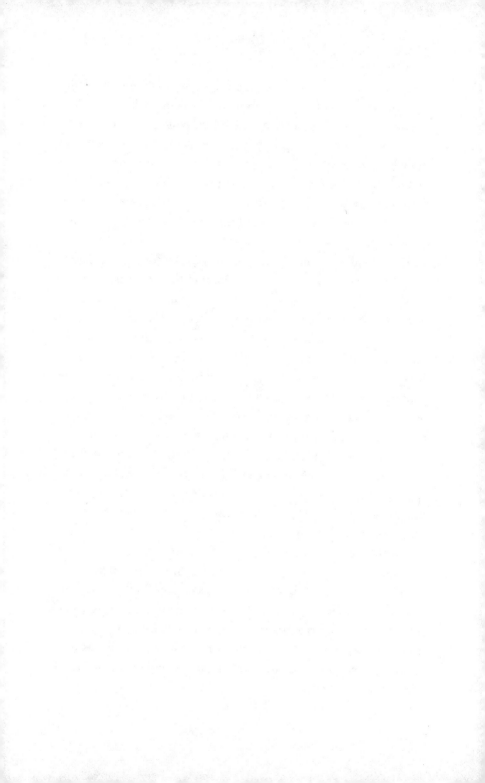

Chapter One

While the Second World War had left Europe devastated and impoverished, America was in the midst of an unprecedented economic boom. It was also, for the first time in its history, a dominant world power. One might expect, then, that the atmosphere in the country would be one of boundless confidence and optimism. But there was little of the comfortable sense of security that other great powers, at the height of their wealth and influence, had felt.

The belief in a benevolent God, in the innate goodness of humankind, in the radiant future that technological progress would make possible, had been shattered by the events of the past few years. The concentration camps had been a revelation of human evil on an unprecedented scale; the development and deployment of the atom bomb had not only made it difficult to regard scientific advances as an unquestionable good, but also for the first time raised the very real possibility that all human life could and might be wiped off the face of the planet, a prospect of total annihilation that no previous generation had had to confront.

As the abstract painter Barnett Newman wrote, "We now know the terror to expect. Hiroshima showed it to us. . . . The terror has indeed become as real as life. What we have now is a tragic rather than a terrifying situation. [No] matter how heroic, or innocent, or moral our individual lives may be, this new fate hangs over us."[1]

The pervasive sense of dread was exacerbated by a growing feeling that another world war was imminent, this time with Soviet Russia as the enemy rather than an ally, and that atomic weapons would inevitably be deployed when fighting broke out. Throughout the late forties, tensions were mounting between the world's last two superpowers, with belligerent rhetoric on both sides. The idea that the USSR must be contained, that America would have to defend itself and the democracies it was pledged to support against Soviet attack, became a commonplace of political discourse. Patriotism became more and more strident, more and more entwined with paranoia, until anti-Communism and love of country were equated in the public mind.

Meanwhile, many of the artists in Pollock's milieu were retreating from politics altogether—not just from the patriotic fervor that was gripping the country but also from the idealistic left-wing allegiances they had formed during the Depression years. It was accepted almost as a given among many American artists and intellectuals of the thirties, including such prominent figures as Theodore Dreiser and Edmund Wilson, that capitalism was in its death throes: its excesses having led to worldwide economic collapse, it was, they claimed, about to be superseded by the rule of the proletariat, the much juster system established in the Soviet Union after the Bolshevik Revolution of 1917.

Nor was it only in America that such ideas held sway. George Bernard Shaw and André Malraux, two of the most famous and celebrated cultural figures of their day, were zealous proselytizers for the Soviet state and the glories of Communism. "Communism

is not hope, but the form of hope," Malraux wrote, and praised the Soviet experiment as "the type of civilization from which Shakespeares emerge."[2] Shaw not only denied that Stalin's collectivization policy in Ukraine was leading to widespread starvation—in fact, an estimated four million people died—but also broadcast a talk on American radio in 1931, urging skilled workmen to emigrate to Soviet Russia, where, he assured them, they would find both a warm welcome and useful employment.

In its attempt to alleviate some of the dire suffering that followed in the wake of the Wall Street crash, the U.S. government itself took unprecedented steps in the direction of what die-hard right-wingers in the Republican Party, a continuously vocal group, chose to call Communism. Roosevelt's New Deal, which at a time of massive unemployment put so many desperate people back to work building bridges and roads and dams (and by doing so arguably prevented revolution, thereby saving American capitalism), even found a way to employ artists, a particular source of outrage among critics of FDR and his advisers.

In 1935, Pollock was one of hundreds of painters rescued from abject penury when he was hired by the Federal Art Project to create paintings for public buildings—post offices, courthouses, schools, administrative buildings. Though never as politically active as some of his cohorts, or as his future wife, he also joined the Artists' Union, which tried to get the government to improve artists' working conditions and provide more secure employment. And the year after being taken on by the Art Project, he volunteered to work with the radical Mexican muralist David Siqueiros, whose passionate left-wing allegiances led him not only to try to create art for the masses, but also to make art out of non-elitist materials, like the Duco paint used for automobiles. It was in conjunction with Siqueiros's activities that Pollock took part in May Day celebrations of solidarity with workers around the world, including in the

Soviet Union, which appropriated the May Day holiday as a workers' celebration after the rise of Bolshevism.

Throughout the thirties, the Soviet Union was seen as not only a workers' paradise but also the chief bulwark against the encroaching Fascist threat in Europe. A certain amount of doubt about the nature of Stalin's government had already begun to set in with the purges of the early thirties and the Moscow Trials of 1936 to 1938—show trials of major Communist Party figures, in which they were sentenced to death on the basis of bogus confessions extracted by torture. But there were still many who defended these developments as just, or at least necessary to further the aims of the revolution. The final blow to all but the most die-hard true believers among American leftists was the non-aggression pact signed in 1939 between the Soviet Union and Nazi Germany.

Though the argument was put forth that the Soviets were simply opting out of a war that would be fought to defend capitalism and imperialism, it became much harder, after that, to go on believing in the moral superiority of Stalin's government. Even when Russia later joined the Allies and fought heroically against the Axis powers, it did not change the fact that it had only switched sides when Hitler, in violation of the treaty between the two countries, invaded the Soviet Union in June 1941. And the USSR's expansionism after the war ended, when it occupied most of Eastern Europe and refused to allow democratic elections there, further eroded much of the old, idealistic support for its form of government.

So however little the avant-garde artists of the immediate postwar period could enter into the patriotic fervor that was gripping America at the time, they had also lost their faith in the alternative system that once claimed their allegiance. Their unease with the belligerent rhetoric of the U.S. government, and its use of the "Soviet threat" as a way of imposing its authority on its citizens, could not dispel their sense that the Soviet Union's acts of aggression

might indeed need to be stopped. In such an atmosphere of disillusionment and confusion and dread, it was almost inevitable that their art would turn inward.

Their move into abstraction can be viewed as a retreat from the socially conscious art that dominated in the thirties into a safer mode of aesthetic expression: if their art no longer contained explicitly political subject matter, it could not be criticized on those grounds. But it can also be seen as a retreat from imagery itself, and hence a purification of the visual. Images had been so co-opted for propaganda purposes, both by totalitarian regimes and in America itself, that they had begun to seem tainted; public language had grown so debased and shrill that artists like Pollock were turning away from it into a private one. Increasingly, they were concerned with exploring the interior mental states that had already begun to claim their attention in the prewar years.

* * *

The work of the Surrealists, which explicitly drew on unconscious sources, had been familiar to New York artists since at least 1936, when it was featured in a major exhibition at the Museum of Modern Art. The cosmopolitan aesthete, collector, painter, and art critic John Graham, who befriended Pollock in the 1930s and is generally regarded as the man who first "discovered" him, saw the Surrealists' playfulness and their use of unconscious material as a liberating alternative to the pure rationalism of Cubism—the other artistic movement that influenced Pollock during this period, and would continue to do so for a long time. Pollock himself particularly admired the paintings of Joan Miró, whose use of calligraphic lines and blobs of paint were to have a great influence on his own work.

Unlike many other avant-garde artists of the twenties and thirties,

the Surrealists always refused to link their work to any explicit political program. Indeed, they rebelled against the whole idea of the programmatic, along with the idea, espoused by various groups of abstract artists after the First World War, that reason and logic were to be the salvation of society. Whereas the geometric abstractionists in particular saw the war as the ultimate outbreak of irrationality, and hence strove to create a purely rational art purged of selfish individualism and primitive impulses, the Surrealists insisted that it was excessive rationality, not its opposite, that was responsible for the carnage, reason being a denial of the *true* reality, which existed only in the unfettered mind. While they were heavily influenced by Freud's ideas about the unconscious, free association, and the primary importance of dreams, they rejected his systematic approach to such things, along with the idea of taming the unconscious by seeking to understand it too closely. Instead, they believed in giving it free rein.

As they saw it, humankind could be liberated only once the false social and cultural strictures that imprisoned the imagination had been demolished. They were much closer to anarchists than to orthodox leftists, much less solemn in their revolutionary aims. László Moholy-Nagy, a Hungarian painter, summed up the vision of many Utopian abstractionists when he wrote, in 1928, "Abstract art . . . creates new types of spatial relationships, new inventions of forms, new visual laws—basic and simple—as the visual counterpart to a more purposeful, cooperative human society."[3] A similar view was expressed by Piet Mondrian when, in a magazine published by the Dutch abstractionists known as the De Stijl group, he wrote that "pure plastic vision should build a new society, in the same way that in art it has built a new plasticism."[4] Such artists believed that their ideas could not only help to regenerate society, but could be made to serve a direct practical purpose if used in the design of housing for workers and other public projects. Meanwhile, the Suprematist

artists in Russia, chief among them the great abstractionist Kazimir Malevich, whose support of the Bolshevik Revolution was absolute, strove to eliminate individualism from painting altogether.

The Surrealists also claimed, with varying degrees of seriousness, to be working towards the overthrow of capitalism, but they felt it could be accomplished only through a revolution in the individual human psyche. Once again, art was to play a key role—but an art of magic and mysticism, rather than reason and harmony. Primitive art was therefore one of their great enthusiasms. (Though the presiding genius of Surrealism, André Breton, known as its "Pope," was a poet rather than a painter, its adherents were mostly drawn from the visual arts.)

After the outbreak of the war, when many of the Surrealists, including Breton, arrived in New York as refugees from Europe, Pollock got to know not only their work, but the artists themselves, and—perhaps even more important—the techniques they had devised for tapping into the unconscious in their art. At the home of the Chilean-born émigré Robert Matta, Pollock began attending regular sessions that featured such exercises as sitting in a circle and drawing blindfolded. Though he did not participate much in the discussions that were a major feature of these gatherings, they had a profound effect on his approach to art. In particular, he was excited by the Surrealists' notion of "psychic automatism," in which the rational mind is suspended or bypassed, allowing the unconscious to take over: Breton, in one of his several Surrealist manifestoes, called it "the dictation of thought in the absence of all control exercised by reason and outside all aesthetic or moral preoccupations."[5] Matta's theory that forms, like emotions, are constantly changing shape, would also have been of interest to Pollock.

In its way, Surrealism was a highly romantic movement, its tenets based on the underlying assumption that it was not a lack of restraint that was to be feared, but restraint itself: according to them,

no control was necessary, suggesting that there was nothing evil in the human imagination or psyche that needed to be controlled. After the war, such an attitude was no longer really viable; Surrealism, insofar as it survived at all, declined into pure frivolity. But the idea of the exploration of the unconscious in art continued to exert a powerful hold. It took Pollock, however, to represent the unconscious in a wholly abstract form, beginning in the late forties: his earlier Surrealist-influenced paintings still contained strong figurative elements, as well as the Cubist forms he "borrowed" from Picasso, with whom, like so many painters of his generation, he became obsessed in the late thirties, remaining so for many years.

* * *

By the time Pollock became involved with Surrealism, his exploration of his own unconscious had been under way in another venue for some time. His difficulties with alcoholism and severe depression led him to be admitted to a psychiatric hospital in Westchester in 1939, and on his release he began seeing a psychoanalyst, as he would do at various periods throughout his life. But it is telling that his first analysis was with a Jungian. The Jungians, much more than the Freudians of the era, were concerned not merely with the childhood traumas and repressed sexual feelings of their patients but with their general spiritual health and their place in the universe.

Whereas Freud wrote of repression and projection and reaction formation, Jung spoke of myths and symbols, the soul, universal archetypes, and the collective unconscious: the shared repository of all the religious and spiritual experiences and feelings of humankind. To Jungians, the individual unconscious was only the most superficial level of the unconscious mind. Though Jung, the son of a Protestant minister, believed that Christianity and all other religions were essentially mythological systems, he did not dismiss them

on those grounds, as Freud did. Instead, he regarded religion as a necessary and fundamental part of human life, the human psyche being religious by nature.

The Jungian approach to the psyche, therefore, was less narrowly rational, more attuned to the mysteries of existence, and less inclined to seek explicit cause-and-effect relations between early traumas and adult emotions. So Pollock's first experience of psychoanalysis went beyond the exploration of his own childhood experiences, into the region of universal myth and metaphysics. For example, his analyst related the "anguished, dismembered or lamed" figures in Pollock's drawings not to fears of castration or latent aggression, as a Freudian might have, but to the state of mind of someone who, engaged in a tribal initiation rite, is undergoing a wrenching transition or entering a trance-state.[6] The totemic figures that began to appear in Pollock's work at this time can be connected as much to his Jungian analysis as to his interest in the Surrealists or the mythological paintings of the Mexican muralist José Orozco that he had grown to admire as Benton's influence waned. Such figures were not allusions to remote classical legends but images with deep psychic resonance.

As a rebellious high-school student in Los Angeles, often in trouble with the authorities, Pollock, who had almost no exposure to religion in his childhood, was deeply attracted to the philosophy of the Hindu mystic Krishnamurti and briefly became a disciple. One of Krishnamurti's key teachings, however, was that each individual must liberate his psyche from within, rather than submitting to any external authority. Pollock could be said to have taken this advice to heart when he ceased being Krishnamurti's follower shortly afterwards. But throughout his life he remained drawn to the thinking of mystics and metaphysicians, those who spoke of a spiritual reality that underlay and transcended the physical one, and that united all living things.

One of the extraordinary things about the American abstract painters of the mid-twentieth century is how powerful a strain of spirituality we find among them—much more than among the Cubists and Surrealists who influenced them or those artists they would influence in turn. Clement Greenberg wrote, "Someday it will have to be told how anti-Stalinism, which started out more or less as Trotskyism, turned into art for art's sake."[7] But in fact, however much they eschewed overt political content, the artists who came to be known as the Abstract Expressionists were not simply aesthetes concerned with formal beauty alone.

Barnett Newman, who called his most famous series of paintings *The Stations of the Cross*, said, "We are reasserting man's natural desire for the exalted." Mark Rothko, whom a poet friend described as "the last rabbi of Western art," wrote of one of his paintings, "[My] picture deals not with the particular anecdote but with the Spirit of Myth. It involves a pantheism in which man, bird, beast and tree—the Known as well as the Knowable—merge into a single tragic idea."[8]

Pollock never went in for that kind of grandiose utterance, but he too was much concerned with the spiritual in art—the title of a book by the great Russian abstractionist Kandinsky, who was himself influenced by the Russian-born mystic Madame Blavatsky. As the critic Robert Hughes notes, Pollock "was preoccupied with such metaphysical questions as he thought art could pose; and the role of art Kandinsky insisted on, the evocation of the 'basic rhythms' of the universe and their vague but imaginable relationship to inner states of mind, was of the most passionate concern to Pollock. In short, Kandinsky gave him a way of incorporating the metaphysical yearnings of American Romanticism into a specifically modern style."[9]

Pollock's abstractions, Hughes goes on to say, are an expression and renewal of "the transcendentalist urge . . . embedded in the

landscape experience of Americans since the days before the Civil War."[10]

This transcendentalist urge was, of course, not limited to the landscape experience of Americans. It was a cornerstone of European and English Romanticism, in which pantheism played a vital part. What the American Transcendentalists of the nineteenth century named the Universal Being or the Universal Spirit was essentially what the great English Romantic Wordsworth called "something far more deeply interfused / Whose dwelling is the light of setting suns / And the round ocean and the living air / And the blue sky, and in the mind of man."[11] American Transcendentalism took its inspiration both from the Romanticism of Wordsworth and his fellow poets and painters and from Eastern religion. But it also had a distinctively American flavor.

While rebelling against traditional Christian orthodoxy, with its conception of a controlling and punishing deity and its insistence that God could be apprehended through reason alone, the Transcendentalists could not wholly embrace the Eastern idea of willlessness, of surrendering the individual ego to attain oneness with the universe. Instead, incorporating the American ideals of personal initiative and the central importance of the individual to any form of endeavor, they emphasized the need for an "active soul" and the part played by personal intuition in apprehending the divinity of the world. They believed not only in the infinitude of spirit but in what the great Transcendentalist Emerson called "the infinitude of the private man"—an idea echoed by the poet Walt Whitman, much influenced by the Transcendentalists, when he wrote, "I am large, I contain multitudes."[12] Like "no limits, just edges," it is a quintessentially American assertion.

Chapter Two

Much has been made of the fact that Pollock was born in Cody, Wyoming, a town founded by none other than Buffalo Bill. Legend had it that Pollock had actually been a cowboy; his early reputation as "the cowboy painter" was particularly thrilling to the French, who were eager to see him as an American primitive, a naïf. Even Robert Hughes, in discussing Pollock's great paintings of the late forties, relates them to "that peculiarly American landscape experience . . . which was part of his natural heritage as a boy in Cody, Wyoming."[1]

Yet he lived in Cody only for the first ten months of his life, and never returned there. He was still a baby when, in 1913, his parents moved with him and his four older brothers to a vegetable farm on the outskirts of Phoenix, Arizona, and only five when they moved once again, this time to a fruit farm in Northern California. Except for a fifteen-month stint back in Phoenix later on, most of his childhood and adolescence was spent in California, first in small towns in the Sacramento Valley and then in a densely forested rural area

sixty miles north of Los Angeles, before he wound up in Los Angeles itself. His one experience of a truly spectacular mountainous landscape as a young man was during the summer he spent with a surveying team near the Grand Canyon, the year before the move to LA.

The family's nomadic existence was driven by the search for a better life that never really materialized. Both of Pollock's parents had grown up poor, in Tingley, Iowa. When Pollock's father, LeRoy McCoy, was three years old, his mother died, and his father gave up on his Iowa homestead, handing his son over to some neighbors named Pollock. His foster parents worked the boy as hard as they could, not only using his labor on their own farm but lending him out to other farmers and making him turn all his earnings over to them. It is even possible that LeRoy's father had sold him to the Pollocks, not such an uncommon practice in those years, which would explain their regarding him not as their child so much as their property, to be exploited for profit.

Though LeRoy never saw his own father again, and cannot have felt much loyalty to the parent who abandoned him, as a young man he tried to have his name changed back to McCoy, presumably because of his bitterness towards his foster parents. But when he consulted a lawyer on the matter, he discovered that the fee to effect the change was more than he could afford. Hence the name of the mean-spirited farmers from Tingley, Iowa, has gone down in art history.

Stella Pollock, Jackson's mother, born in a two-room cabin in Tingley a year before LeRoy, had had to leave school after the sixth grade to help look after her six younger brothers and sisters. But at least she grew up with her own parents. Like her mother, and her weaver ancestors back in Ireland, Stella was skilled at working with her hands; a lover of beautiful things, a fine seamstress, she not only made all her own family's clothes but also earned money sewing for

the rich women of the town. (Later she would become just as skilled at driving teams of horses, wringing chickens' necks, and milking cows.)

If the Pollocks' move to the boomtown of Cody had been motivated by a desire to claim some of the free land that Buffalo Bill was offering to newcomers, they were disappointed: it turned out that the offer was contingent on having the money to build a house on that land, which like so much else was beyond their means. Instead of farming, LeRoy worked as a dishwasher in Buffalo Bill's hotel and then joined a friend from back home in a rock-crushing business, which damaged his health so badly that after a few years he could not continue with it. So he took a job managing a sheep ranch. It was on this ranch, in a two-room frame house, that Paul Jackson Pollock was born, after a difficult labor, on January 28, 1912. Then came the move to Arizona.

LeRoy seems to have been happy in Arizona, and the farm, if not exactly prosperous, was supporting the family, but Stella felt the schools in the district weren't good enough for her boys. Hence the move to Northern California, where their fruit farm failed, as did an attempt to run a hotel in the area.

From the time Pollock was eight, his father lived with them only very intermittently, though he never failed to send money home out of his meager wages, and never lost touch with his sons; it was through his father that Pollock got the job with the surveyors. Still, the fact remains that Pollock grew up virtually fatherless, except for a brief period when Stella decided to rejoin LeRoy, by then back in Arizona, hoping they could be a family again. Her husband, however, showed little sign of wanting to live with her. For a time, she worked as a housekeeper to a widowed farmer in Phoenix to support her sons. Then it was back to California again.

Every time they moved, Pollock, always known as Jack within the family, started at a new school, doing poorly in each of them,

unable to make friends, too bashful to ask girls out but given to sudden profane outbursts that got him into trouble with the school authorities. In his freshman year of high school, he dropped out after being expelled from ROTC for assaulting a student officer who had reprimanded him. It was probably alcohol that had fueled his bravado in this incident; already, by his early teens, he had started experimenting with drinking, as had his brothers before him.

*　*　*

The dominant figure in the five Pollock boys' lives, Stella always envisioned a better life for her sons than the drudgery of manual labor to which she and their father were condemned. It was largely her influence that led them all to pursue careers as artists, though it was her eldest son, Charles, who showed the most early talent, and who the family was convinced would be the great painter among them. In 1921, Charles announced his intention to study at the Otis Art Institute in Los Angeles. Stella was delighted. Shortly afterwards, both Jackson and his brother Sanford, the second-youngest of the sons, announced their own intention to become artists. But when Jackson made that statement, he had never, according to his brothers, produced a single drawing. Nor, to the best of anyone's knowledge, had he ever been in a museum: there were no such things in the farm country of Arizona and California. Such knowledge as he had of art came from reproductions in the art books both Charles and Stella loved and the Native American artifacts he had seen when visiting the reservations in the area.

One of his brothers later said that anyone who looked at Pollock's early work would have advised him to become a plumber instead. Pollock himself, in a letter to Charles, lamented the fact that his drawing lacked "freedom and rythem [*sic*]"—the two qualities that would characterize his greatest work almost twenty years later.[2]

It is an interesting question whether the most radical innovators are not sometimes those who have no facility for conventional work. Although Picasso was a brilliant draftsman (and there are those who feel his art remained draftsmanlike rather than painterly throughout his life), Cézanne, who launched virtually all the radical movements in twentieth-century art—both Picasso and Matisse called him "the father of us all"—certainly lacked the facility of a Degas or a Manet. His clumsy, dogged early work was hardly more indicative of a gift for art than Pollock's. It may be that the fierce struggle to overcome or circumvent a lack of conventional gifts sometimes, if coupled with latent genius, leads to huge breakthroughs.

When Jackson was sixteen, the entire family moved to Los Angeles. He enrolled at the Manual Arts High School, supposedly to study industrial arts. But the only class that really excited him was a painting course taught by a radical exponent of Modernism. (It was through this man, also, that Pollock came to know of Krishnamurti, whom the teacher invited to come and address his students.)

At Manual Arts, he found his first real friends: fellow students Manuel Tolegian, the son of Armenian immigrants, and Phillip Goldstein, whose parents were poor Eastern European Jews. Later Goldstein changed his name to Guston and became a well-known painter himself. More articulate, more obviously talented, more politically aware than Pollock, the two young men took him to meetings of Communists, got him copying Renaissance paintings—Pollock was no good at it, as he himself recognized—and involved him in their work on a subversive newsletter they had started.

In 1930, Pollock moved to New York to join Charles and Frank, who had gone there to study at the Art Students League on 57th Street, the most informal and flexible of the art schools in the city, and encouraged him to do the same. Though his time in Manhattan was marked by even greater poverty and insecurity than his

upbringing had been, it would remain his home for fifteen years. Except for his brief spell in the Westchester psychiatric hospital, a few trips out west, and a few summers he spent on or around Cape Cod, he stayed there throughout the Depression and the war. It was longer than he ever lived anywhere else. When he moved away, in 1945, he went to Springs, Long Island, just 125 miles from the city, where he lived for the remaining eleven years of his life, with frequent trips into Manhattan and sometimes month-long sojourns there.

So however much he loved open spaces—one of the chief attractions of Springs was its proximity to the ocean, whose vast expanses brought to mind, as nothing else in the East did, the western landscape—and however much his upbringing in the West influenced his sense of scale, his aesthetic sensibility cannot be explained as stemming from his origins in Wyoming. Nor can his paintings be viewed as the spontaneous productions of a cowboy artist, a "primitive" operating on nerve and instinct alone. They represent a highly sophisticated and individualistic response to the Cubism of Picasso, the Surrealism of Miró, the mythological paintings of Orozco, the abstractions of Kandinsky, and other international Modernist influences.

But the cowboy image remains, and it is easy to understand why. The photographs and films in which Pollock appears, as well as many written descriptions of him, convey a raw physical vitality—the same explosive force and dynamism present in his paintings—that is typically associated with the non-urban man, the man who has lived an outdoor life and gone untamed by civilization. Coupled with Pollock's extreme taciturnity, something for which the denizens of New York City are not known, it created the impression of a gruff, laconic westerner, an American hero of a particular kind.

By and large, Americans did not place the same value on articulateness that many European cultures did. Too great an agility with

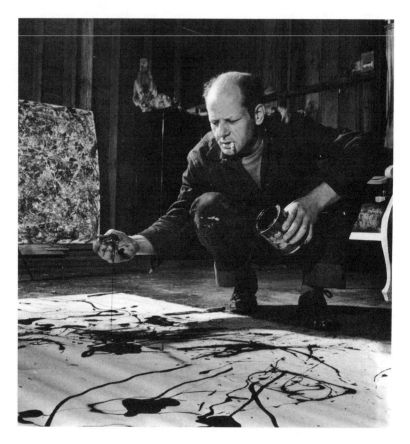

© Martha Holmes/*Time & Life* Pictures/Getty Images.

language was considered slightly suspect, for men in particular. The principled man was one who said little and felt much, who did not use words to charm, flatter, or seduce, but only to speak the blunt truth in as few words as possible. It was the silent man of action who was admired, while fluent verbal skills were considered the province of the snake-oil salesman, the con artist, the lounge lizard; no honest man, and none with real inner strength, was supposed to evince the gift of gab. "Talk low, talk slow, and don't say

too much," was John Wayne's advice.[3] At the very least, the need or even the ability to put everything into words was considered unmanly; hence the strenuous efforts of various American writers to prove their macho credentials by such antics as getting into the ring with boxers.

Certain of Pollock's fellow artists—particularly Mark Rothko and Barnett Newman, quoted in chapter 1—were much given to expounding on the meaning of their work and explaining its underlying philosophy. Products of a highly verbal Jewish culture, they believed in the power of words to illuminate and persuade, and in their own ability to make their work understood. Like various groups of European artists, among them the Surrealists, they issued statements, pronouncements, and manifestoes; they challenged the prevailing views of their time as much in words as in their art. Pollock, by contrast, when forced to speak about his paintings, answered hesitantly, and his replies were as simple and brief as possible. He avoided making any grandiose claims for his work, nor would he tell people how they were supposed to look at it, except to say that he hoped they would enjoy it as they enjoyed flowers and music. His suspicion of intellectualizations about art was such that, according to de Kooning, "he had contempt for people who talked."[4]

Pollock's refusal to explain his art is surely not unconnected to his iconic status. As the English novelist Jenny Diski has written, "The true icon excites the curiosity without ever answering the questions it demands you ask. Enigma depends on an essential silence."[5]

But his taciturnity extended beyond a reluctance to talk about his paintings. His distrust of words, or inability to summon them at will, was such that his Jungian analyst could not even get him to talk about his problems, which meant the analyst had no material to work with in their sessions. To surmount this obstacle, he came up with the idea of having Pollock bring along drawings to his office,

which the analyst would then talk about himself, treating them as psychoanalytic material in the same way that dreams were. (Fourteen years after Pollock's death, these drawings would become the center of a controversy when the analyst sold them to a San Francisco art gallery, prompting cries of outrage from both the art world and his professional colleagues.)

In the presence of others, particularly strangers, he might remain silent for hours. When a friend of Lee Krasner, his future wife, first encountered him at Krasner's studio in Greenwich Village, she assumed that the man in overalls who was sitting in a corner and never said a word the whole time must be a local handyman, maybe one who didn't speak English.

What remains to this day Pollock's most famous utterance was exactly three words long. Krasner had studied with the well-known German-born abstractionist Hans Hoffman in New York, and she wanted Hoffman to come see Pollock's paintings. Indeed, she wanted everyone to come see Pollock's paintings; she was more than willing, in those days when nobody knew who he was, to speak for him, to tell everyone he was a great painter. (It was Krasner who first brought Clement Greenberg to Pollock's studio, too.) Hoffman looked at Pollock's paintings and, with what may have been a trace of condescension, expressed concern that their subject matter seemed to come entirely from within. Sooner or later, he said, that source would be exhausted, and Pollock would have to venture outside himself for inspiration. "Look at nature," Hoffman advised the younger painter. "I *am* nature," Pollock told him.[6]

It is, of course, a supremely macho statement, the assertion of a hugely ambitious ego. But the aggression implicit in machismo was mostly absent in Pollock when he was sober. Under the influence of alcohol, however, his shy, polite persona disappeared, as did his taciturnity. Many people, especially his fellow painters, testified to his articulateness when he had a few drinks; when he had too many,

he picked fights, shouted insults, threatened violence. Even if he merely sat glowering, his presence when he was drunk became frightening; the raw physicality that he projected took on a menacing, Stanley Kowalski aspect that unnerved the people around him. Yet despite his macho, this was a man who had never been able to live on his own, who needed desperately to be looked after.

As the youngest of the Pollocks' five sons, he was always regarded by the fiercely maternal Stella as her baby. He was the only one who was never asked to help with the chores, and the one whom everyone in the family was expected to protect and take care of. For almost all of the first ten years he was in New York, his brother Sanford—who was not only closest to Pollock in age, but had always been closest to him emotionally when they were growing up—made himself responsible for him and looked after him with almost maternal solicitude. When Sande, as he was always called within the family, had a chance to leave New York in 1937, a particularly bad period for Pollock, he refused it, against his own inclinations, out of concern about what would happen to Pollock when he was left on his own.

Insofar as possible, Sande propped Pollock up and shielded him from the consequences of his own disturbed behavior. It was Sande who, with the help of a cultivated elderly woman who had decided that Pollock was a genius, and until her death did all she could to help him, first got him into analysis; it was Sande who helped him up the stairs to the apartment they shared when Pollock was too drunk to climb them himself; it was Sande's heroically forbearing wife who cleaned the apartment and cooked for him and did his laundry. Sande, said Pollock's Jungian analyst, "carried much of [Pollock's] reality function . . . his frequently missing attention to reality was admirably being supplied by his brother."[7]

Meanwhile, Sande tried to keep the severity of Pollock's problems a secret from the rest of the family. Only when Stella was

considering moving to New York, in the late thirties, did Sande finally write to Charles and confide in him that he thought it would be disastrous for their troubled brother to have their mother around, as many of his problems undoubtedly stemmed from his relationship with her. It seems like an accurate diagnosis.

It is notable that Pollock had never had a real relationship with a woman at that time. Some people have claimed that he was more sexually attracted to men, which would probably have terrified him, given the importance he placed on machismo. But whether or not that's true, there can be no doubt that his feelings about women were highly conflicted. A painting from the early thirties shows a massive, powerful nude figure with hideously distorted breasts and legs spread wide, her head flung proudly, triumphantly back; she is surrounded by tiny, almost ghostlike creatures, dwarfed by her massive bulk. Later paintings would depict women as similarly powerful and threatening. "Dads beat their young; Moms eat them," he told a friend many years later (rather a bleak view of family life). And "All mothers are giants."[8]

* * *

For his first few years in New York, Pollock was looked after not only by Sande and his wife but also by his teacher at the Art Students League, Thomas Hart Benton, who virtually adopted him, as he had Pollock's brother Charles before him. In a city that was the center of the avant-garde in America, the Missouri-born Benton stood out for remaining defiantly, pugnaciously American, unimpressed by European art in general and Modernism in particular. Benton had returned in disgust from Paris to help develop a truly American art, one that defied the trend towards abstraction and the effeminacy of Modernism. Ironically, though he regarded his "kinetic," swirling forms as an homage to the Mannerism of the

Renaissance, his work looks similar to the Socialist Realism that was the officially sanctioned art of the Soviet state, something that outraged Benton when it was pointed out to him: having renounced the radical Marxism of his youth, he was virulently anti-Communist.

Benton's "American Scene" art may have found particular favor in the thirties because of the highly politicized atmosphere of the period. Given the grim realities of the Depression, Modernism—which had never really taken firm root in America anyway—seemed like a luxury that only aesthetes operating in a more prosperous time could afford. Certainly, in literature, the whole trend of the decade was towards an art of political engagement, one that dramatized the plight of those disenfranchised by the Wall Street crash, and this strain was also evident in the visual arts, though there was less homogeneity. Politically, Benton was much further to the right than most of the artists of his time, but his work, which depicted laborers and farmers and harmonica players and fiddlers at square dances, reflected a belief in the patriotic duty of the artist that was widespread at the time. Thomas Craven, one of the leading critics of the day, expressed the view of many when he said, "We can no longer turn away from the significance of the subject-matter of art. America lies before us, stricken with economic pains, but eager for the voice of criticism, and in desperate need of spiritual consolations. Shall we face the situation like honest workmen, or shall we hide in the dark tower and paint evasive arabesques on ivory walls? . . . I have exhorted our artists to remain at home in a familiar background, to enter emotionally into strong native tendencies, to have done with alien cultural fetishes."[9]

During Pollock's time at the Art Students League, his paintings were essentially attempts to reproduce all of Benton's effects, in depictions of the same sort of subjects as Benton's. It has often been pointed out that even the wholly abstract works he created much

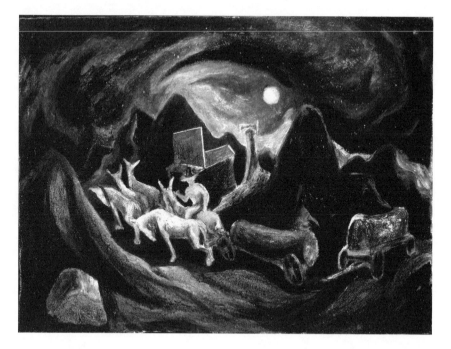

Going West, c. 1934–38. 15 1/8 × 20 7/8 in. © 2011 The Pollock-Krasner Foundation / Artists Rights Society, New York. Reprinted by permission of Smithsonian American Art Museum, Washington, DC / Art Resource, NY.

later incorporate Benton's sinuous, rhythmically undulating forms. But movement, even violent movement, was so much an expression of Pollock's temperament that the prevalence of rhythm in his paintings cannot be wholly ascribed to his apprenticeship with Benton.

Benton's most lasting influence on Pollock may have been not on his art, but on his persona. A swaggering, hard-drinking figure, Benton was almost as well known for his use of profanity and his aggressively rude public pronouncements—especially about Modernists and Communists—as for his work. Pollock later called him the "biggest little man I ever met."[10]

Whatever the nature of his influence, Benton was the first real mentor in Pollock's life. Pollock spent almost as much time at the New York apartment of Benton and his wife, Rita, as at his own, eating Rita's Italian cooking, helping her with the dishes, and telling stories of Wild West heroes to the Bentons' young son. For several years running, he stayed with the Bentons at their summer home on Martha's Vineyard, where they gave him his own "shack" on the property to live in. When Benton accepted a teaching position in Kansas City in 1935, they invited him out there for Christmas. With them, as with nobody else then or later, he was unfailingly gentle. Rita Benton, whom he adored, was always hatching schemes to help him, including, in the period of his greatest poverty, persuading several small galleries in New York to handle his work. (The story goes that one of the few sales he made during this period was of a Bentonesque watercolor sold to none other than Katharine Hepburn; unfortunately, she returned it to the gallery two days later.)

By the time Lee Krasner came along, the Bentons were long gone from New York, and Sande's wife, who had once sworn that she would not have a child as long as she had to live with Pollock, had just had a baby. She and Sande were leaving the city and moving to Connecticut. So Pollock was about to find himself on his own for the first time.

Born in 1908, four years before Pollock, Krasner was the daughter of poor Jewish immigrants from Ukraine, and the first of their children to be born in America. She had grown up in Brooklyn in a largely ghettoized environment, speaking Yiddish at home, helping her father with his fish stand in the market. In school she decided to be an artist, and she pursued that goal with fierce determination. After her escape to the Village, where she abandoned her birth name of Lenore Krassner, she became an established figure on the

downtown art scene as well as a committed leftist, actively involved in trying to bring about social change.

In November of 1941, John Graham, who was something of a mentor to Krasner as well as Pollock, arranged an exhibition that, for the first time, would hang the work of young American painters next to that of Picasso, Matisse, and other European Modernists. In addition to Pollock, he chose the Dutch immigrant Willem de Kooning and other, better-known American painters like Stuart Davis to appear in the show. Krasner was the only woman he included.

Because Pollock's was the one name on the list that Krasner didn't recognize, she asked around about him until she found out where he lived—just around the corner from her own apartment, as it happened. (When he came to the door, she recognized him as someone she had danced with at an Artists' Union party five years earlier, when he had stepped all over her toes.) By her own account, she was knocked out by his paintings: "To say that I flipped my lid would be an understatement. I was totally bowled over by what I saw. . . . I felt as if the floor was sinking when I saw those paintings."[11]

A fiercely independent woman, an ambitious artist in her own right, Krasner seemed to defy all the feminine stereotypes of the period. She had never bothered to make so much as a cup of coffee in her apartment before she met Pollock. Yet she dedicated herself wholly to the job of looking after him, acting as not only his promoter within the art world but also his caretaker and cook and nurse, and performing those roles, for better or worse, up until the final month of his life.

The man-child is as much an American figure as the he-man cowboy, the other side, perhaps, of the same persona, with his own kind of powerful emotional appeal and sometimes tragic consequences for both him and those around him. As the writer James

Baldwin caustically observed: "This ideal [of masculine sexuality] had created cowboys and Indians, good guys and bad guys, punks and studs, tough guys and softies. . . . It is an ideal so paralytically infantile that it is virtually forbidden—as an unpatriotic act—that the American boy evolve into the complexity of manhood."[12]

The complexity of manhood was what Pollock achieved in his paintings.

Chapter Three

Krasner first climbed the stairs to Pollock's apartment in November 1941. In the following month, the Japanese attacked Pearl Harbor, and America was at war. One of the immediate effects was the winding down of the Federal Art Project, known by then as the Program, which had come under mounting attack as the exigencies of war increasingly required that resources be allocated elsewhere. After a brief period working under Krasner doing window displays for the Program's War Services Division, and another stint as a "trainee in aviation sheet metal," Pollock was let go, along with all the other Program artists, in January 1943.

He had already been classified 4F—unfit to serve in the armed forces—due to his alcoholism and depressive illness. For several months, he had to resort to painting ties and printing designs on scarves and plates in order to scrape by. Finally, he was hired by the Baroness Rebay to help run—really to work as a janitor at—her new Museum of Non-Objective Art, an institution wholly funded

by her wealthy lover, Solomon Guggenheim. But that job did not last for very long either.

It was Guggenheim's niece, the flamboyant heiress Peggy Guggenheim, who became Pollock's rescuer. Though she had been born and raised in New York, Guggenheim had lived in Europe for more than twenty years; during her time there, she became first an exhibitor, and then, particularly in the months just after the outbreak of war, an avid collector of the European Modernists. While living in Paris shortly before the Germans arrived, she made it her policy, she said, to buy a painting a day. By the time she and her collection arrived in New York in the summer of 1941, she had acquired ten Picassos as well as numerous works by the Surrealists. (She had also acquired the Surrealist painter Max Ernst, whom she brought back with her when she returned to New York, having helped him to escape German-occupied France after he had been arrested by the Gestapo. They were married shortly after their arrival in New York.)

Guggenheim had run a contemporary art gallery in London in the late thirties and then planned to open a museum of modern art there, an idea she was forced to abandon when it became obvious that war was imminent. Art of This Century, the gallery she opened in New York, was therefore a sort of substitute for her museum, and primarily conceived as an exhibition space for her own collection: one room was devoted to the Cubists, another to the Surrealists, and a third to kinetic art, a particular passion of hers. Only a single room was set aside to display work she proposed to sell. Yet her gallery became the city's leading private venue for contemporary art during the war years.

In the New York of that time, there were only about a dozen commercial galleries, most of which sold more traditional sorts of paintings; by and large, it was the museums, not the galleries, that

introduced advanced art to Americans. Nor was there undiluted enthusiasm for the work of the Europeans flooding into New York. Another of Henry Luce's magazines—*Fortune*, which was aimed specifically at people in the business world and more generally at the affluent reader—defined the cultural situation in phrasing suggestive of the Gettysburg Address: "The unprecedented exodus of intellectuals from Europe confers upon the U.S. the opportunities and responsibilities of custodianship for civilization. . . . The great questions are whether, during American trusteeship, Europe's transplanted culture will flourish here with a vigor of its own, or languish for lack of acceptance, or hybridize with American culture, or simply perish from the earth."[1]

Guggenheim did not propose or expect to profit financially from Art of This Century; nobody at the time seriously regarded being an art dealer in New York, especially one who showed Modernist art, as a money-making endeavor. As a New York dealer said more than fifty years later, when things had changed radically, "Peggy loved art and meant to help artists—dealers of her generation were into the general aesthetics of what they were doing."[2] And although she has been much criticized for her flamboyant behavior and her undoubted egotism, as well as accused of not actually knowing very much about art—like many another patron of artists, she reaped more sneers than gratitude—she most certainly did help artists. She also knew enough to pick the best possible advisers when she was deciding on either purchases for her own collection or the artists to include in the shows she mounted.

Art of This Century, Guggenheim said, would "serve its purpose only if it succeeds in serving the future instead of recording the past."[3] Her gallery was itself an avant-garde spectacle, with some paintings projected outward on sawn-off baseball bats, others hung on curved walls, and lights that flickered on and off. At first, Guggenheim intended to show only European art, but later she decided

to invite young American artists to submit their work for a juried competition. She also invited the great Dutch abstractionist Piet Mondrian, for whom she felt a respect bordering on awe, to serve on the jury.

Pollock submitted a painting that, like all his work at this time, contained both Cubist and Surrealist elements, with recognizably Picassoesque shapes and Miró-like squiggles. Later titled *Stenographic Figure*, it conveys the impression of, while not actually depicting, a reclining female, ambiguously situated in the space of the painting. Guggenheim originally dismissed it with scorn, only to find Mondrian gazing at it with intense interest; when, in response to her derisive comment, he called it the most exciting painting he'd seen since coming to America, she promptly changed her mind about its worth. At the urging of her young gallery assistant, Howard Putzel, who felt that in Pollock he had discovered an authentic American genius, she not only gave Pollock his very first solo exhibition in November 1943—which was also the first one-man show devoted to an American artist at Art of this Century—she also provided him with an allowance that enabled him to survive.

The paintings Pollock exhibited at Guggenheim's gallery during the war years continued to show the influence of Picasso and Miró and the Surrealists while also asserting his American roots, in part by using Native American, or simply American, imagery within a European compositional framework. The most explicit example is in a painting called *The She-Wolf*, in which the figure of the bull so often used by Picasso appears on one side of the canvas and the American buffalo on the other. In other paintings, there appear an Indian headdress, arrows, and the zigzagging patterns associated with Native American art.

In *Male and Female*, he created a fantastically orderly composition that included many disparate elements playing off against each other, with Surrealist images contained within a geometric Cubist

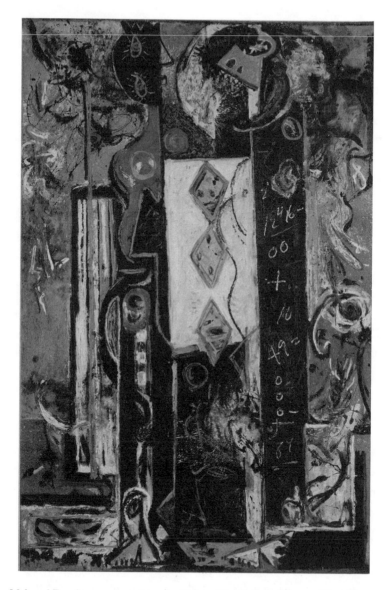

Male and Female, c. 1942. 73 × 49 in. © 2011 The Pollock-Krasner Foundation /
Artists Rights Society, New York. Reprinted by permission of the Philadelphia
Museum of Art / Art Resource, NY.

structure. The tension between the formal rigor, even tightness, of the composition and the playfulness of some of the images and markings within it—squiggles, scrawled numbers, brightly colored bug-like shapes with myriad wavy legs, along with freewheeling, wholly abstract splatters and whorls of paint that prefigure the later work—is maintained without ever appearing disharmonious. At the same time, despite its many cheerfully bright colors, it's a faintly sinister painting in its way, with something unsettling about the ambiguously male and female figures of the title. (The bug-like shapes could also be the eyes of the cat-like head of the female figure; a grotesque, clumsy, harshly yellow horse's head, mouth open in what could be a scream, topped by a ragged mane, could be the head of the male figure.) Though it may still be a synthesis of others' ideas, rather than the profoundly original art that would come later, to contain so much within a single canvas without losing control, and without producing the effect of overcrowding, is itself a masterly achievement.

In *Guardians of the Secret*, another highly innovative painting that appeared in his first show at Art of This Century, we see Pollock starting to break away still further from European painting. Although there are very strong symmetrical elements, as in Cubism, there are looser, more spontaneous-looking passages extending right to the top of the canvas, and the imagery is taken from Native American, African, and prehistoric art. Like several of Pollock's other works of this period, *Guardians of the Secret* presents us with huge male and female figures, highly abstracted but still barely recognizable. Flanking the wholly non-figurative central panel, they are imposing, totemic presences, who might be the priest and priestess of some ancient religion. Overall, the painting conveys a sense of dramatic grandeur, yet, again, there is also a freewheeling quality to it, particularly in the bright furious squiggles and images that dance above the central rectangle.

Another painting he was working on during this period, but which was not completed in time for his first show with Guggenheim, brings him one step closer to his later style of painting. Called *Pasiphae*, after the figure in Greek myth who fell in love with a bull and gave birth to the Minotaur (the name was given not by Pollock, who had never heard of Pasiphae, but by a curator at the Museum of Modern Art), it is not composed in the European sense, with a central structure, but is instead worked into every inch of the canvas. It's as though, with each painting he did, Pollock was pushing farther and farther out towards the boundaries of the canvas; in *Pasiphae*, he arrived right at its edges.

At the same time that Guggenheim offered Pollock his first solo show at her gallery, she also commissioned him to paint a mural for her apartment. Two of the most famous and widely repeated stories about Pollock center on this mural. Both have been called into question by some scholars, though never convincingly refuted in their entirety; both, whether true or apocryphal, are part of his romantic legend.

The first story has to do with the mural's creation. In July, Pollock knocked down a wall between his and Krasner's studios in their Eighth Street apartment to create a big enough space for a twenty-foot-long painting; he bought the canvas, he bought the paint. But for weeks, then months, according to Krasner, nothing at all happened with the mural.

When his show at Art of This Century came down and there was still no sign of it, the story goes, Guggenheim began to complain, to expostulate, to make the sort of imperious threats for which she was notorious. In December, using Krasner as her emissary, Guggenheim gave Pollock an ultimatum: he absolutely must deliver the painting to her apartment in time for a party a visiting friend of hers was giving there in January. Apparently, she hinted that otherwise the allowance would stop. But even that, in Krasner's account,

failed to spur Pollock on. He spent hours sitting in the room with the blank canvas, staring at it in gloomy silence. He sent Krasner off to stay with her parents, hoping that being alone with the canvas would release him from his block, but when she returned, there was still not a single mark on it.

On the night before the party, Krasner said, she went to sleep in the certain knowledge that the next morning they would have to confess defeat; they might even be losing Guggenheim's patronage for good. But instead, when she woke up, the painting was finished. In the course of a single night, Pollock had covered 180 square feet of canvas with densely evocative forms. The mural remains a landmark work in Pollock's oeuvre, one of his signature paintings.

In his review a few weeks earlier, Greenberg had somewhat disparaged two of the paintings in Pollock's show as partaking of "the blandness of the mural."[4] Can Pollock have set out to show him that a mural need not be bland? Certainly his approach was wholly different from that of most mural painters, who tended to work on one section at a time, moving in a linear fashion along the canvas or the wall, and to plot out the work beforehand through drawings done to scale.

According to his own description of how the painting evolved, Pollock began by setting down an image from his life out west—the mustang herds he had seen during the summer when he joined his father on a surveying crew in the Grand Canyon. They moved across the canvas in a stampede, turned into men, turned back into horses, into bulls, a series of fluid shapes drawn with paint. In the painting as we know it, there is no recognizable figurative imagery, only what Pollock referred to as "veiled" images, but it still gives the sense of a stampede, of a particularly sinuous, dance-like kind. It is all swirling, pulsating motion, with no geometry to it—no rectangles or straight lines or slashing diagonals. Nor does it have any single still point or center of focus, any formal relationship between

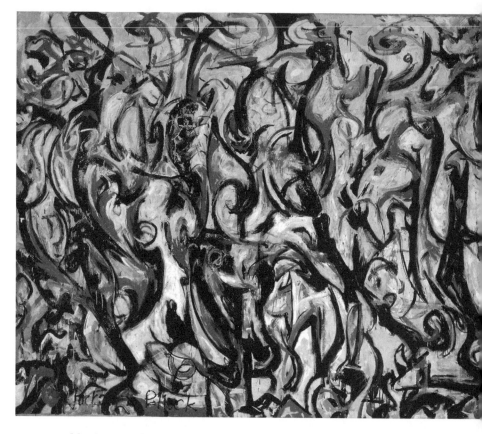

Mural, 1943. 7 ft. 11 3/4 in. × 19 ft. 9 1/2 in. © 2011 The Pollock-Krasner
Foundation / Artists Rights Society, New York. The University of Iowa Museum
of Art, Gift of Peggy Guggenheim, 1959.6.

the different parts of the whole: it is instead an "all-over painting,"
as his work of this kind would come to be known. Whatever the
truth about its creation, it *looks* like a painting that was completed
in one session, in an unbroken rhythm: the rhythm of the painting
itself is unbroken, an exultant surge of color, life, movement. In
the words of the late Kirk Varnedoe, who served as chief curator of

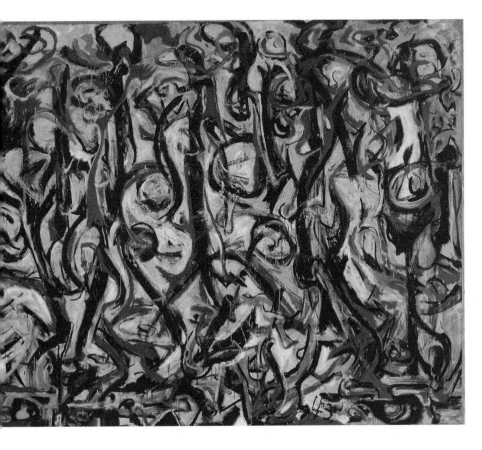

painting and sculpture at the Museum of Modern Art and orga-
nized the comprehensive Pollock exhibition there in 1998, "When
you look at the picture, it's clear that no matter how long it took
him to paint this picture, he never thought twice during the whole
time he was painting it."[5]

Sooner or later, however hard one tries, it is impossible to avoid
using the word "energy" when speaking of Pollock's work. The
mural for Guggenheim is the first of his paintings to manifest the
kind of explosive energy we associate with him. Unlike the later

all-over paintings, it still has a certain narrative feel to it, as well as a sense of pictorial recession. But the swirling black lines that pull the painting together are not outlining the shapes; they have been painted over them, breaking down the figurative elements. We do not need to ask what the subject of this painting is, what it is "about." It does not refer to anything outside itself. Like the great drip paintings Pollock would make later on, it simply *is* itself. (The irony of Pollock's abstractions is that, while they do not represent any objective reality, in another sense they are, by virtue of their powerful physicality, anything but abstract: as objects, they are about as concrete, as overwhelmingly present, as you can get.)

The second story featuring the mural is probably the most famous one told and retold about Pollock. According to the legend, after he had delivered the painting to Guggenheim's apartment— where it turned out to be slightly too long for the wall, and none other than Marcel Duchamp, who had been dispatched by Guggenheim to help Pollock hang it, had to get his permission to chop off eight inches at one end—he proceeded to get drunk, wander into the living room where Peggy's friend's party was in progress, and urinate in the fireplace.

Perhaps it really happened. He would almost certainly have gotten drunk, if only because the mural was finished and he was surrounded by strangers. And those strangers were more interested in talking to each other, or flirting with each other, than in looking carefully at his painting. Pollock would not be the first artist, or the last, to feel angry and humiliated at people's indifference.

Or maybe he simply had to urinate, and with the mad logic of the drunk, the fireplace struck him as a sensible place to do so. But it is a bit suspicious that some versions of the story have him walking into the room naked, while others have him clothed and simply unzipping his fly. And though it's the one story everyone seems to know about Pollock, there is not a single eyewitness account of the

incident. Nor has anyone ever said what he did next: Did he pass out in front of the fireplace, did he slug one of the guests, did he proposition the hostess? It would have been a hard act to follow.

Whatever the true story behind the creation and hanging of the Guggenheim mural, it remains a seminal work in both Pollock's oeuvre and the history of art. To quote Kirk Varnedoe again:

> He was then, and would remain for several years more, a
> provincial. Yet for a moment in January, when he put down
> the brush after the concentrated hours moving back and forth
> across the twenty feet of Mural, and painting from the floor to
> as high as his reach would stretch, this man stood alone at the
> head of the class, not just in New York but internationally. He
> had redefined not only the parameters of his own abilities but
> the possibilities for painting, at a moment when the fortunes of
> modern art—and the prospects for a continued liberal ideal of
> modern culture—were at a nadir. There was nothing of this
> power and originality being made anywhere else in the war-
> plagued world that dim winter. And he had done it—doubtless
> somewhat in a spirit of desperation, having boxed out all other
> alternatives—by trusting himself, and leaving a lot to the
> inspiration that would come in the process of making.[6]

Chapter Four

Though he was gaining a reputation among the downtown artists, Pollock's second show at Art of This Century, which took place in the spring of 1945, was, if anything, even less of a commercial and critical success than his first exhibition there. There were no sales at all, and Clement Greenberg was the only critic who praised it with real fervor. Greenberg wrote in the *Nation*: "Jackson Pollock's second one-man show at Art of This Century establishes him, in my opinion, as the strongest painter of his generation and perhaps the greatest one to appear since Miró. The only optimism in his smoky, turbulent painting comes from his own manifest faith in the efficacy, for him personally, of art. There has been a certain amount of self-deception in School of Paris art since the exit of cubism. In Pollock there is absolutely none, and he is not afraid to look ugly— all profoundly original art looks ugly at first."[1]

Greenberg, a quintessential Jewish intellectual of the period, a lapsed Marxist, was almost as little known as Pollock when he wrote

those words. He would later become not only Pollock's most famous avatar but arguably the most influential American art critic of the century. Over the next few years, he propounded two ideas that had a far-reaching influence on the way people thought about art, and even the way they made it.

The first concerned the death of easel painting, which he saw as an outmoded art form. It was not an entirely new idea—shortly after the Russian Revolution, the institute assigned to identify the role of art under Communism had condemned easel painting in similar terms, and the leftist Siqueiros had also reviled it as a form of fascism. There may have been a lingering Marxist tinge to Greenberg's own stance on the matter. Though his argument was not a crudely political one, the fact remained that easel painting was an essentially bourgeois format, meant to hang in the homes of the middle and upper-middle classes and on the walls of the museums patronized by them.

His second theory, which eventually exerted an even greater influence, was that the more an art form evolves, the more "autonomous" it becomes, in the sense that it will emphasize whatever inherent qualities and limitations are unique to it, as a way both to criticize and to define itself. Since painting's unique characteristic was that it was two-dimensional, his argument went, the most advanced painting had ceased trying to create an illusion of depth, as the paintings of the past had done. Instead, it deliberately emphasized and drew attention to its innate flatness, the fact that it was simply marks on canvas. As he would later write, "Realistic, naturalistic art had dissembled the medium, using art to conceal art; Modernism used art to call attention to art. The limitations that constitute the medium of painting—the flat surface, the shape of the support, the properties of the pigment—were treated by the Old Masters as negative factors that could be acknowledged only

implicitly or indirectly. Under Modernism these same limitations came to be regarded as positive factors, and were acknowledged openly."[2]

* * *

In the summer after his first show at Art of This Century, Pollock and Krasner had gone to Provincetown, on Cape Cod, for several weeks. (It was in Provincetown, in that summer of 1944, that Tennessee Williams, who was also there, witnessed some of Pollock's Kowalski-like behavior.) In the summer of 1945, after his second show at Guggenheim's gallery, they once again left the city. This time, they visited artist friends who had rented a summer place in the tiny fishing and farming community of Springs on Long Island's South Fork, a poor cousin to its neighbor: the elegant summer resort, much frequented by artists, of East Hampton. Pollock spent the summer fishing, swimming, and cycling along the narrow roads; he dug for clams in the bay and played with their friends' young children. He was still drinking, but primarily beer, which never had as disastrous an effect on him as whiskey. When they returned to Manhattan, he decided that he wanted to move out there.

If it was the Atlantic Ocean, the one geographical feature of the East that reminded him of the western landscapes he missed, that drew Pollock to Springs, Krasner hoped that getting away from the city, never his natural habitat, might cure him of his depression and his compulsion to drink. Despite her best efforts and the treatment he was undergoing with her trusted homeopathic physician, always, after a period of intensive work, he would spiral downwards again. When drunk, especially in bars, he would shout insults, throw punches at strangers, pick fights he could not win. Barmen refused to serve him, or even to let him in; sometimes people refused to fight him because he was so obviously psychologically disturbed.

And sometimes he passed out in the gutter and spent the night there. Meanwhile Krasner would spend hours pacing the floors of the apartment, waiting for him to come home, or she would go out looking for him in the bars, as Sande used to do. Now she placed her faith in the healing properties of country living, as many others had done before her.

Not that they could possibly afford to buy a house, even the house Pollock had in mind, which, perhaps because it had no plumbing or heating, and was in bad shape generally, was priced relatively cheaply, at $5,000. A nineteenth-century clapboard farmhouse, it had five acres, a barn Pollock could use as a studio once some necessary repairs were carried out, and a potential view—after the barn had been moved, as it would be the following summer—right across the marshes and out to Accabonac Creek and Gardiners Bay. The sense of boundlessness, of infinite space, evocative of the skies and the landscapes of his childhood, would, after all, prove to have a profound influence on the paintings he would make in Springs. So Krasner was not entirely wrong in thinking that a move to the country would mean a new beginning, even if it did not provide a cure.

The local bank, it transpired, would give them a mortgage if they could come up with a down payment of $2,000, a sum so unmanageably huge to people in their position that they should really have abandoned the idea there and then. There being only one person of their acquaintance who could possibly lend them that sort of money, Krasner went to ask Peggy Guggenheim to help them. According to Guggenheim's account, she was in bed with a cold when Krasner came to ask if they could borrow the $2,000. She refused on repeated occasions, she said, but each time Krasner came back the next day, sat down on her bed, and asked again, until finally Guggenheim agreed to lend them the money just to get rid of her.

So in November of that year, Krasner and Pollock, who were by then Mr. and Mrs. Jackson Pollock—they had been married in the

city the month before, with the cleaning woman of the church where the ceremony took place as one of their witnesses—moved out to Springs. The move would prove to have a dramatic effect not only on the future direction of American art, but also on property values on the South Fork of Long Island. But that was a long time off yet.

* * *

If Springs had been largely untouched by the Depression, it was because it had never known prosperity. It was one of those insular communities, of the kind more often associated with the backwoods of New England, whose residents prided themselves on weathering hardship rather than trying to free themselves from it. People with money, people with education, were regarded as soft, lazy; they gave themselves airs and lacked true grit. And here was this "crazy artist," rumored to have rich backers in the Sodom and Gomorrah known as New York City, come to live among them.

At least, though, he seemed no better off than they were. "It was hell on Long Island," Krasner recalled.[3] "It was a rough scene we walked into. . . . The house was stuffed from floor to ceiling with the belongings of the people who had lived there. The mackinaw of the man who had lived there was still hanging on the rocker in the kitchen. . . . The barn was packed solid with cast iron farm tools. It was a matter of cleaning everything out before we could move in or work."[4]

Having cleared out the junk and torn out walls to create a single large room downstairs, they decorated the house with shells and driftwood they found on the beach, pebbles, bits of broken glass, and striped gourds. They could not afford to install central heating or a bathroom. Pollock even had to borrow money from the woman who ran the local bar and grill where he went for breakfast. But he

always paid her back. If the residents of Springs continued to regard Pollock as lazy—it was well known that he never got up before noon—some of them developed a slightly grudging liking for him nonetheless. And they in turn were not so different from the people he had grown up among. He was back in America. He could have dogs again, as he used to when he was young; he even adopted a crow. It was Krasner, born and bred in a Jewish immigrant community in Brooklyn and then part of the left-wing, avant-garde art scene of Greenwich Village for many years, who was really out of place.

The war was over, but there were still its aftereffects to deal with. The materials they needed to repair the house were hard to get hold of, as was the coal for the stoves that provided their only heat; the place was ice-cold that first winter, and the toilet often froze during the night.

If the physical discomforts of their new life were daunting in themselves, there were also what looked like troubling developments in the art world. The European artists who had flooded into New York in the late thirties and early forties were now returning to Paris, which they still regarded as the real center of culture. So were many American artists, who were eager for the firsthand exposure to European Modernism that had been denied them by the war. And Peggy Guggenheim was going with them. It is doubtful that she had ever intended to settle in her native country for good, but even if she had once entertained the idea, by 1946 she had gone sour on both America and Art of This Century.

Her husband, Max Ernst, who had almost certainly married her only to escape the situation in Europe, had left her for Dorothea Tanning, a young American painter who would later become his fourth wife. Various American artists she had shown had likewise absconded, in their case to her professional rivals: since the war, several other contemporary art galleries had opened in midtown

Manhattan. Art of This Century was no longer the unique phenomenon it had been at its founding.

Guggenheim gave Pollock two further shows at her gallery before it closed. The first of these, in April 1946, was generally regarded as a disappointment; the densely worked, often thickly painted canvases in the show, though more richly, even joyfully colored than anything Pollock had attempted before, have a busy, slightly claustrophobic quality, as though he had been trying to crowd a large painting onto a too-small canvas. Even Greenberg considered it a falling-off from Pollock's previous show, though he still found things to praise about the work and concluded, with uncharacteristic humility, "It is precisely because I am still learning from Pollock that I hesitate to attempt a more thorough analysis of his art."[5]

Since the studio was not yet ready to work in, Pollock had been painting in a smallish upstairs bedroom in the house, a fact that may account for the sometimes cramped appearance of the work he produced. Certainly, once he'd had the barn moved that summer and cleared it out for use as a studio, his work opened up dramatically. His next and last show at Art of This Century would mark a turning point, one at which the paintings that, above all others, we associate with Pollock first began to emerge.

He began to use the wrong end of the brush to gouge and scratch into the painted surface; his relationship to paint itself, and to his tools, was growing freer, bolder, more physical. He was experimenting with premixed industrial paints—fluid paint that did not have to be squeezed from a tube, mixed with a medium, and applied with a brush in a linear sequence. He started to manipulate his paints with sticks. He even pressed his paint-covered hands onto the canvas, creating strangely skeletal-looking prints. He also included the detritus from the studio in the work: cigarette ends, matches, nails, tacks.

He placed his canvases on the floor, unstretched, and moved

around them, or sometimes rotated them to work on them from different angles, a technique used by the printmaker Stanley Hayter, with whom Pollock had worked back in New York. Whereas formerly Pollock had "veiled the image," obscuring any recognizable representational forms by layering paint over them, he now dispensed with the image altogether, though he did not do so all at once. Like his mural for Guggenheim, the paintings he began making in 1946 were all-over works—paintings that, as one of the *Life* panelists pointed out in 1948, had no beginning, middle, or end. "He didn't mean it as a compliment," Pollock said, "but it was. It was a fine compliment."[6]

And then he started pouring or hurling or spattering paint directly from the can, controlling the patterns it made with the motions of his body, hands, and arms. Working swiftly, moving rhythmically around the canvas like a shaman performing a ritual dance, he acquired a physical grace he did not have at any other time. When he did make use of a brush, it was often as a tool for drawing in space—flicking paint onto the canvas from above to create thick, flowing, continuous lines, whorls, dense skeins, complex webs of paint. Then he would kneel on the floor and, extending his body over the canvas, deftly flick more paint, or draw with a stick in the paint he had already applied. He used trowels, too, and knives. He had not only liberated painting from the easel and the wall; he had even liberated it from the brush.

He too was being liberated during this period, from the besetting curse of his life. In 1948, a kindly young general practitioner in East Hampton, whom Pollock began seeing weekly, accomplished what a whole series of therapists had never managed to achieve: he got Pollock to quit drinking. According to Pollock, it was a simple matter of finally having found someone he could trust. When Krasner asked him how Dr. Heller had effected such a miraculous cure, Pollock said, "He is an honest man, I can believe him."[7] Though

Heller also gave him tranquilizers to take when the tension might otherwise have led him to drink, he found after a while that he did not need them very often.

It's surely not coincidental that Pollock was finally able to go on the wagon when his work in the studio was taking off as never before; the self-doubt that had plagued him for so long was allayed at last. It's probably not coincidental, either, that during the two years he was sober he went on to do his greatest work.

Chapter Five

It has been contended with increasing frequency over the years that the term "drip paintings" is inaccurate. According to many scholars and critics, Pollock did not drip paint; he poured it (he also splattered, splashed, and hurled). Hence the preferred term in academic and curatorial circles is "poured paintings." But it seems a slightly precious designation. As Pepe Karmel, then a curator at the Museum of Modern Art, pointed out in defending his own use of the term "drip paintings," Pollock himself described his process as "dripping fluid paint."[1] And as the *New Yorker* critic Peter Schjeldahl wrote in a review of a Pollock show in 2006, "To call Pollock's procedure 'pouring' [is] a fussy nugget of jargon with no support from the dictionary. (Poured paint plays a supporting role in only some of the work.) Not just more accurate and time honored, the vulgar 'drip' resonates with a still potent shock of naked materiality which Pollock originated and which has been a major trope in new art (it was decisive for minimalism) ever since. If we want to be precise about what Pollock did—drawing in the air above a canvas

with a paint-loaded stick—the mot juste is 'dribble.'"[2] Since "dribble paintings" sounds derogatory, the term "drip paintings" will be used here.

It is amazing—and amusing—how many sources people have cited for the drip paintings. Many of them are plausible as far as they go. It is true, for example, that Hans Hoffman, Krasner's teacher, had experimented with dripping and pouring paint as early as 1940. It is equally true that Arshile Gorky, the Armenian-born Abstract Expressionist whose work Pollock had seen first in Manhattan and later when they were both living on Long Island, used drips in his paintings. It is undoubtedly the case that William Baziotes had a "drip period," that Francis Picabia had sprayed ink on paper, that at Siqueiros's New York workshop paint was dripped or splashed on the canvas with a stick prior to beginning work, to see what kind of imagery it suggested.

At Stanley Hayter's New York atelier, there was something called a compound pendulum, a paint can suspended from two strings, which when let go made patterns on whatever material was beneath it. Like Hayter, Marcel Duchamp made use of a can of paint on a string, while Max Ernst had punched holes in a bucket of paint and swung it over a canvas laid flat on the floor. (Ernst always claimed that Pollock had stolen the idea from him.)

As early as 1914, the great Impressionist Monet was creating large-scale "all-over" paintings, such as his famous *Water Lilies* series, almost abstract works in which the illusion of perspective is abandoned for the play of light, color, and texture. These paintings are at least as much about paint as they are about water lilies—it has been suggested that, in honor of Monet and his influence on the group, the Abstract Expressionists should really have been called the Abstract Impressionists instead.

In the New York of Pollock's day, the American painter Mark Tobey exhibited "all-over" paintings with some of the same calli-

graphic qualities as the drip paintings, but by all accounts Pollock never saw the 1944 exhibition in which they appeared. He did, however, see the modest-sized drip paintings a little-known painter named Janet Sobel exhibited at a group show in the same year at the Art of This Century Gallery. "Pollock (and I myself) admired these paintings rather furtively," Clement Greenberg wrote, describing Sobel as a "'primitive' painter" (others used the term "naïve") and noting that she "was, and still is, a housewife living in Brooklyn."[3] Rediscovered after her death in 1968, Sobel, who seems to have been almost universally condescended to during her lifetime, has finally received full credit for her part in alerting Pollock to the possibilities of dripping paint.

But Sobel's paintings are much more restrained and decorative than Pollock's, while Tobey's are deliberately, consciously tranquil, inviting contemplation. Pollock's do not really *invite* anything; instead, they are confrontational, demanding a certain surrender. The sense of movement within them, the feeling of being compelled to follow the painter through the movements he made to create them, add immeasurably to their impact.

The very size of certain drip paintings also induces a physical response. By now, it has become commonplace for painters to work on huge canvases, just as it was in the Renaissance. (Veronese's *Feast in the House of Levi*, completed in 1573, was much larger than any Pollock.) But for a hundred years or so before Pollock, easel painting had been the dominant format. He was both rescuing a very old tradition and remaking it in a radically new form.

Yet not all these canvases are on a monumental scale by any means; there is as much variation in size as there is in the effects and textures Pollock was able to achieve with his drip technique, both from painting to painting and within one individual work. Sometimes the impression is of fine tracery, sometimes of a raw, rough crust; sometimes the calligraphic lines look like handwriting, sometimes

they are jagged and fierce, sometimes sinuous and lyrical; sometimes the effect is of clouds or spiders' webs, sometimes of lightning bolts or electrical charges. The lack of explicit narrative content makes the viewer more keenly aware of the paint itself, the sheer materiality of the surface, even while it eliminates the sense of narrative time to create an experience of an eternal present.

In a sense, the drip paintings are exemplary Greenbergian works. They are not illusionistic; they are simply marks on canvas, woven patterns of paint. In that sense they are depthless. Yet they also convey a sense of cosmic space, at times even of depth.

Again, we cannot avoid using the word "energy"—the overwhelming impression of the great Pollocks is one of immense power, a raw, explosive *aliveness* that some have chosen to call aggression and others an essentially religious ecstasy. It is the sense of anarchic vitality being given form that lends the drip paintings their excitement. Greenberg said, "Pollock's superiority to his contemporaries in this country lies in his ability to create a genuinely violent and extravagant art without losing artistic control."[4] But violence is not the whole of it. Pollock has found a way of containing something that seems uncontainable—whether we call that something violence or madness or a vision of the sacred. The writer Richard Yates could have been speaking of Pollock (though he wasn't) when he made the point that art does not *impose* order on chaos—in fact, he said, that was the opposite of art, which brings order *out of* chaos.

Nietzsche, in *The Birth of Tragedy*, defined great art as essentially a marriage between two conflicting forces, which he named after two diametrically opposite Greek gods. There is the Apollonian, containing force, which gives the work form and creates harmony, providing relief from the suffering of the world; then there is the Dionysian force, the orgiastic, primordial essence—madness and wildness, but also ecstasy, in which it is possible to lose oneself and

become part of a larger consciousness. Art that is purely Apollonian, purely the product of reason and will and form, cannot fully release the spectator from isolation, or fully express the untamed human spirit. But art that is purely Dionysian is ultimately not art at all, because it will lack all form, and form is the only vehicle through which we can apprehend the Dionysian essence.

It would be absurd to pretend that Pollock deliberately set out to combine the Apollonian and the Dionysian in his work. Even if he had read *The Birth of Tragedy*, or someone like Greenberg had talked to him about it, he would hardly have taken it as an instruction manual. Still, there are few works of art that seem to illustrate Nietzsche's theory as well as the drip paintings. In the best of them, there really is a sense of going beyond an individual consciousness into something more universal and mysterious.

That's why it is reductive to interpret Pollock's talk of expressing his unconscious in his work as simply referring to his own emotional state. The drip paintings, so far from being a direct personal expression, allowed him to transcend the personal. The material on which he was drawing when he painted them—the "subject," if you like, of these paintings without any explicit subject matter—seems to have more to do with the Transcendentalists' "Oversoul," or universal spirit, than with any repressed traumas. One can argue that the drip paintings have their source in the collective unconscious, as defined by Jung, rather than in Pollock's individual one. As the critic Jerry Saltz wrote, the drip paintings "are a manifestation of an idea that has been with us since the Burning Bush: the fire that does not consume. Pollock's paintings bear witness to an artist reaching into fundamentally sacred precincts of existence."[5]

The form they took, however, was very much a product of the age he was living in. As he himself said, "The modern painter cannot express this age, the airplane, the atom bomb, the radio, in the old forms of the Renaissance or of any other past culture." (Or, as

Kandinsky wrote in *Concerning the Spiritual in Art*, "Every work of art is the child of its age and, in many cases, the mother of our emotions. It follows that each period of culture produces an art of its own which can never be repeated.")[6]

Seen in the context of the era in which they were made, a few years after Hiroshima and Nagasaki, the impression of something fragmenting, shattering, *exploding*, the sheer force with which these paintings confront the viewer, conjure up the specter of the atom bomb, with its connotations of power and dread. For all their rhapsodic, exultant qualities, they also provoke, or express, a sense of anxiety; the tension in them between two seemingly contradictory emotions is yet another source of their power. At the same time, they embody the idea of the atomic makeup of matter—the realization that nothing in the material world is actually solid and impermeable, but is instead made up of an uncountably vast number of random particles. It is this species of disintegration that his work manifests, rather than any disintegration of the psyche.

Seen in formal art-historical terms, the drip paintings represent a synthesis between painting and drawing that nobody had ever achieved before. As Kenneth Baker, the art critic for the *San Francisco Chronicle*, has said, "Pollock's great accomplishment was to unify line and color, to give coherence to a large surface without ostensibly designing it, and to make the smallest details seem alive to the eye without detracting from the larger energies of the picture."[7]

* * *

Surrealism's emphasis on suspending the workings of the rational mind clearly played a role in the evolution of the drip paintings. But many American influences can be cited as well. The one Pollock himself alluded to was the sandpaintings of the Navajo and other Native Americans of the Southwest. Part of a religious healing

ritual designed to vanquish illness or evil by restoring harmony and balance, such paintings are created not by craftspeople but by a tribe's medicine man, who walks around, chanting, as he pours the sacred colored pigments—colored sand, powdered minerals, powdered roots, crushed flowers, pollen, charcoal—onto the floor of the ailing person's dwelling. Most sandpaintings depict a story from Navajo mythology in symbolic form. The patient sits in the middle of the painting, which is believed to absorb the illness into itself. For that reason, it becomes toxic and has to be destroyed once the ceremony, which can also involve songs, prayers, and dancing, is complete.

There are intriguing, even poignant, resonances here—the idea of making paintings as part of a religious ceremony, the idea of their healing properties (Pollock had much need of healing), the idea of the shaman's power to summon forth spirits to banish evil and misfortune and restore harmony to the universe; even, perhaps, the idea that it is the making of the painting that counts, not its survival as an object. But the most practical aspect of sandpaintings as an inspiration for Pollock is, obviously, that they gave him the liberating idea of placing his canvas on the floor, thereby freeing him from the need for a single perspective. Like the medicine man, he could then move all around it, entering the space of the painting in a more immediate, physical way.

As he told it, "On the floor I am more at ease. I feel nearer, more a part of the painting, since this way I can walk around it, work from the four sides and literally be *in* the painting."[8]

Apart from the makers of the sandpaintings, the other American artist whose influence can be detected is Albert Pinkham Ryder, a nineteenth-century painter whom Pollock, in the first interview he ever gave for publication, called "the only American master who interests me."[9] Often described as a visionary, Ryder, who lived a life of solitary poverty, created mood pieces of a particularly evocative,

emotionally haunting kind; they are both intensely personal and suffused with a sense of the supernatural. Whether he was painting the sea or taking his subject matter from Shakespeare or opera or the Old Testament, he was not concerned to depict his subject in the illustrative, naturalistic style of so much nineteenth-century American painting, but instead transformed it into a reflection of his own brooding, anguished inner state.

Ryder also prided himself, rightly or wrongly, on having taken nothing from European masters, on having created a purely American art. In this respect, he was actually *un*like Pollock, who, while acknowledging that "an American is an American and his painting would naturally be qualified by that fact, whether he wills it or not," refuted the idea of "an isolated American painting," calling it "absurd to me, just as the idea of creating a purely American mathematics or physics would seem absurd."[10]

* * *

The nineteenth-century English aesthete Walter Pater said that "all art constantly aspires to the condition of music. . . . In its ideal, consummate moments, the end is not distinct from the means, the form from the matter, the subject from the expression.'" Or, as the critic George Steiner has written, "The energy that is music puts us in felt relation to the energy that is life; it puts us in a relation of experienced immediacy with the abstractly and verbally inexpressible, but wholly palpable, primary fact of being."[11] Beginning with the mural he painted for Guggenheim, Pollock's work got closer and closer to the condition of music—specifically, to jazz, the one indubitably, quintessentially American art form, which Pater might not have recognized as music at all.

The form of the drip paintings emerged as Pollock worked on them; he did not make sketches or work out in his mind beforehand

what he intended the finished canvas to look like. Instead, like a jazz musician improvising on a theme, he relied on his instinctive sense of what worked, what the painting itself called for, once the process of making it was under way: "When I am *in* my painting, I am not aware of what I am doing . . . the painting has a life of its own. I try to let it come through."[12]

Also like a jazz musician, he made use of accident and chance, though Pollock, understandably defensive about suspicions of his artistry, was at pains to minimize the role these played in his process: "I *can* control the flow of paint; there is no accident," he said, and "I don't use the accident—'cause I deny the accident."[13] Yet, as we have seen, he used whatever materials happened to fall on the canvas as he worked, incorporating cigarette ash, cigarette butts, and dead insects into the work at various junctures, as well as the broken glass and sand "and other foreign matter" that he added deliberately.

The freer his paintings became, the more they seemed to tap into some of the same "primitive," preverbal impulses as jazz—to express, like jazz, the workings of the unconscious, not through the use of symbols but directly. Like jazz, they convey a sense of exultation, of urgent, rhapsodic feeling just barely contained—the Nietzschean tension between wildness and form. (It is telling that Nietzsche identified that state of ecstasy and wildness with Dionysus, the god of wine; jazz musicians are more notorious even than Pollock for their use of consciousness-altering substances of various kinds.)

Like jazz, the drip paintings give the impression of freewheeling immediacy and spontaneity—a distinctively American quality—while exhibiting the same high-wire discipline necessary to avoid spinning out of control. Neither Pollock nor a great jazz musician improvises from scratch; there is a huge fund of skill and knowledge, of knowing the moves, that is being drawn on in the act itself.

But perhaps the most striking point of resemblance is the way both are governed by rhythm.

A passionate aficionado, Pollock told Krasner that jazz was "the only *other* creative thing happening in the country."[14] But though it is always progressive jazz that his work is likened to—especially the edgy, radically experimental music of Charlie Parker, who like Pollock renewed the art form in which he worked through his own originality and daring—when it came to jazz, Pollock was a conservative. Rather than Parker and bebop, he listened to the more traditional musicians he had first heard when he was young, people like Louis Armstrong and Count Basie and Duke Ellington.

The drip paintings have also been compared to other types of art, particularly the poetry of Walt Whitman—not, as might be thought, because they too represent a "barbaric yawp," or a "song of myself," but for evoking what the poet and critic Carter Ratcliff called "a sense of limitless possibility," a "pictorial equivalent to the American infinite that spreads through Walt Whitman's 'Leaves of Grass.'" "In the work of both painter and poet," according to Ratcliff, "the lack of hierarchical structure is the prerequisite for what is positive about their work: its power to image forth a political premise still basic to America's idea of itself. . . . Whitman and Pollock propose an equality too thoroughly unqualified to be guaranteed by the constitution, or protected by law or promoted by daily life."[15]

Robert Hughes sees the drip paintings as Whitmanesque not because of their egalitarian principles but in their evocation of the spiritual grandeur of the American landscape—what Whitman called "that vast Something, stretching out on its own unbounded scale, unconfined, which there is in these prairies, combining the real and the ideal, and beautiful as dreams." In the drip paintings, Hughes writes, "Pollock was certainly evoking that peculiarly American landscape experience, Whitman's 'vast Something.'"[16]

As the American poet Charles Olson wrote, "I take SPACE to be the central fact to man born in America, from Folsom Cave to now. I spell it large because it comes large here."[17]

* * *

There has even been an attempt to explain the drip paintings' power in mathematical terms. In 1995, Richard Taylor, a physicist who was also an artist and a student of art history, detected certain distinctive patterns repeated over and over on different scales within a given painting, a phenomenon found in certain shapes known in chaos theory as fractals. Fractal properties have been found to appear in many natural objects, such as snowflakes and coastlines, in which the same irregular pattern is repeated at different magnifications. It has been suggested that humans' ability to perceive fractal patterns is part of their survival equipment: awareness of fractals could have allowed those living on an African savannah, for example, to determine whether the grass had been ruffled by the wind or by a dangerous predator.

According to Taylor, the fractals in Pollock's paintings occurred at different levels of complexity, becoming more complicated as he developed his technique. Whereas the fractal patterns of the earlier drip paintings correspond to those in nature, those in the later works, he contended, are far more complex. Taylor then conducted a survey to see which types of fractal patterns people preferred and discovered that, in 80 percent of cases, they were drawn to the same level of fractal to be found in nature. So he reported that the drip paintings generally regarded as Pollock's greatest have the most pleasing fractal dimensions. (Of course, Taylor was not suggesting that Pollock set out to create fractal patterns that replicated those in the natural world; his theory was that he had achieved that effect instinctively.)

Unfortunately, Taylor's fractal analysis technique, which for several years was taken seriously enough to be enlisted as a tool for determining the authenticity (or otherwise) of disputed Pollocks, was later called into question. In 2002, two other physicists concluded that Taylor's method was too oversimplified to be meaningful; they found that the same fractal patterns he had discovered in Pollock's work could also be found in a childish scribble. But for a time, at least, it seemed as though Taylor had conclusively refuted the notion, put forward by *Life*'s indignant readers and Pollock's other detractors, that the drip paintings represented nothing but chaos. Instead, it seemed, they were an illustration of chaos *theory*, quite a different matter.

Chapter Six

After the October 1948 *Life* article appeared, Pollock told a friend that the abstract painter Franz Kline had said it "changed my life." According to this friend, he went on to say, "I bet you *Life* will change my death. It won't be in bed, wait and see."[1]

The spread in *Life* engendered a seismic shift in both the scope of Pollock's fame and the situation of avant-garde art in America. When de Kooning famously said of Pollock that he "broke the ice," he was referring not so much to the breakthroughs in Pollock's art (though he also said Pollock had "busted our idea of a picture all to hell") as to his having made it possible, for the first time, that the downtown painters who came to be known as the Abstract Expressionists might actually find an audience for their work.[2] All of them would benefit, directly or indirectly, from Pollock's success, and the buzz of excitement around the new American art that it had generated. For the first time, their sort of painting had attracted attention beyond the confines of the downtown art world, which meant there was finally at least a glimmer of a possibility that they would

sell enough work to scrape by, rather than accepting dire poverty as their lot in life.

Franz Kline, whose poverty meant he was living mostly on coffee with a lot of sugar in it, was looking after a friend's dog when he returned to his studio one day and found the dog dead, with a half-eaten bar of soap beside it. It proved, he said, that not even a dog could survive the life that artists had to lead. As the poet and critic Weldon Kees wrote, "From an economic standpoint the activities of our advanced painters must be regarded as either heroic, mad, or compulsive; they have only an aesthetic justification. . . . One is continually astounded that art persists at all in the face of so much indifference, failure, and isolation."[3]

The years preceding his appearance in *Life* had been some of the most poverty-stricken of Pollock's life—and he had never known affluence. In 1948 and early 1949, his first two shows with Betty Parsons, the dealer Peggy Guggenheim had persuaded to take him on when she closed Art of This Century, sold so badly that he considered taking up sign painting or fabric painting or teaching to earn a living.

He applied for a Guggenheim grant, in which he echoed Greenberg's thesis that the easel painting was a dying form and murals the way forward, but the committee turned him down. He and Krasner had spent the winters huddling around the tiny stoves that were the only source of heat in the house; at times, if there was no money for wood, they had no heat at all. Parsons, who some said was too sensitive and tenderhearted to be cut out for the business side of running a gallery, was so appalled by the way they were living that she wound up begging people to buy his paintings; sometimes she didn't deduct the commission she was owed on whatever work she managed to sell. Even their far-from-rich neighbors in Springs felt sorry for them, though when the kindly owner of the local general

store agreed to take a drip painting in payment for groceries, everyone thought he was crazy.

But all that was about to change. America, with its newfound wealth and power, and its burgeoning media, was hungry to establish its preeminence on the cultural stage as well. It was the only area in which the country still felt some sense of inferiority to bombed-out, impoverished Europe. The consensus among critics and collectors alike was that French art still reigned supreme, an uncomfortable state of affairs which, it was felt, had to be put right somehow. In the same month that the *Life* piece appeared, T. Soby, a respected columnist and art critic for the *Saturday Review of Literature*, wrote a sort of clarion call, reminiscent of Henry Luce's rallying cry about creating an American century: "We have produced in painting and sculpture no figure big enough to hold the eyes of the world on himself and also, inevitably, on those of lesser stature around him. Even so, we can take hope from a curious fact about giants in the arts: when you get one, the rest come easily. We await our first . . . certain that he will appear, and others like him."[4]

Clearly, America was ready—hungry, even—for a genius to emerge in the visual arts. And it was fortuitous that Pollock, the painter singled out by Greenberg as the "strongest . . . of his generation," should have been so very American a figure. Of the other leading figures in Abstract Expressionism, de Kooning was an immigrant from Holland, Rothko from Russia; Barnett Newman had grown up in a Jewish immigrant community in New York; Arshile Gorky, in many ways the forerunner of the Abstract Expressionists, was a refugee from the Armenian genocide. (In any case, Gorky was dead, a tragic suicide, by the time Soby wrote those words.) Robert Motherwell, though American-born, was the product of an upper-middle-class background; his father was a bank president, and he had even attended Harvard. Quite apart from the merits of his paintings,

therefore, he was not as romantic a figure as Pollock. Only Clyfford Still, a fellow westerner, might have done almost as well for propaganda purposes.

* * *

It was no longer necessary for people to understand Pollock's art in order to believe in it; there were enough of them ready to take it on faith that he was the "giant" they had been looking for. To buy his paintings became not only proof of superior cultivation but also an act of patriotism. There was also the prospect, for the first time, that his art might appreciate in value: soon *Fortune* magazine would begin advising its readers on which sort of art was likely to prove the best investment.

For all those reasons, there were many more sales from his third show at the Betty Parsons Gallery, in November 1949, than Pollock had ever had before. (Perhaps prospective buyers were also influenced by the fact that the drip paintings he showed were much smaller than his monumental works, hence easier to find room for on people's walls.) Eighteen paintings sold, one to Mrs. John D. Rockefeller III. There were also sales to the artist Alfonso Ossorio, a wealthy East Hampton neighbor who became Pollock's greatest and most discerning patron, as well as a loyal friend and supporter, and to the art critic Harold Rosenberg, another neighbor on Long Island. Most of these paintings were numbered rather than named, Pollock having decided by then that titles, which encouraged people to search for images and references that were not there, were misleading for paintings such as his. (Titles had always been a sort of afterthought with him anyway, and many of his earlier works had been given names by people who saw them only once they were finished; some of the titles thus supplied referred to myths and symbols Pollock himself knew little about.)

In keeping with the ethos of the moment, the reviews of the 1949 Parsons show were almost uniformly respectful, although they did not offer much insight into the work. "A pleasingly large repeat design gathers momentum as it moves from left to right," the *New York Times* reviewer wrote.[5] (He could be talking about wallpaper, or the necktie the *Life* panelist had scoffed at a Pollock canvas for resembling.) The following month, when one of Pollock's paintings was shown at the Whitney Annual, the reviewer for the *New York Sun* was equally polite and bland, acknowledging that "the spattering is handsome and organized" and "the composition looks well in the entrance hall."[6]

Time magazine, however, even though it was the sister publication to *Life*, owned and published by Henry Luce, was not persuaded. Having already ridiculed Pollock's work in a short piece two years earlier, it ran a review of the Whitney Annual in which it sneered at the abstract art on display: "Jackson Pollock's nonobjective snarl of tar and confetti, entitled *No. 14*, was matched by William [*sic*] de Kooning's equally fashionable and equally blank tangle of tar and snow."[7]

It would not be the last of *Time*'s attacks on Pollock—what the Luce magazines gave with one hand, they took away with the other. But *Time* could not destroy Pollock's new cachet. He began to be interviewed not only by the art magazines but by journalists from other types of media. One of the few extant recordings of his voice comes from a taped radio interview in which he tries to explain, with seeming embarrassment and reluctance, how his own work, and modern art in general, should be looked at, and what its concerns are: "The modern artist is working with space and time, and expressing his feelings rather than illustrating."[8]

The controversy over abstraction even made it onto the front pages of the *New York Times*. In the spring of 1950, the Metropolitan Museum of Art announced that it would hold a juried competition

for a show to be called "American Painting Today—1950"; all the artists chosen for inclusion would then be eligible to receive the prize money that a further jury would allocate. Neither of these juries, however, was likely to favor the work of the kind of artists in Parsons's stable, which by that time included many of the Abstract Expressionists. Rather than entering the competition and facing certain rejection, they decided to write a letter of protest about the Metropolitan's choice of judges, who were all, they said, "notoriously hostile to advanced art." Not only was their complaint reported on page 1 of the *Times*, it occasioned much press coverage elsewhere as well. Pollock could not get to New York to sign the letter—he sent the museum a telegram of support for the protest instead—but he did make it into the city for a photograph of the letter's signers, which would accompany an article in *Life* in January 1951. "IRASCIBLE GROUP OF ADVANCED ARTISTS LED FIGHT AGAINST SHOW," read the caption, and the eighteen artists in the photograph became known as the Irascibles, although they look much more gloomy than irate.

With the exception of Arshile Gorky, all the key figures of Abstract Expressionism are there: Willem de Kooning, Mark Rothko, Barnett Newman, Adolph Gottlieb, Robert Motherwell, Clyfford Still. (The Romanian-born painter Hedda Sterne is the only woman; Krasner, a much stronger artist but one relegated to the role of wife in the eyes of the group, was not invited to join the protest.) Pollock is in the center, leaning into the camera and holding a cigarette aloft; as in practically every photograph in which he appears, he mysteriously commands the viewer's attention.

The Irascibles' statement made no mention of the political ramifications of their art, but as modern painting attracted more attention in the media, it also came under increasing attack. Back in 1947, Secretary of State George Marshall, the progenitor of the Marshall Plan to rebuild Europe, had been forced to recall a show

of "Advanced American Art" that was traveling overseas, after President Truman and others expressed incredulity that taxpayer money was funding such disgraceful junk. "If that's art," Truman said, "I'm a Hottentot."[9] (The art in question was not even particularly radical compared to that of Pollock.) The attack became much more political when, in 1949, a U.S. Congressman stood up in the House of Representatives and gave a speech entitled "Modern Art Shackled to Communism," specifically citing the Abstract Expressionists as allied to the Communists and declaring that there was an explicit link between "the Communist art of the 'isms' and the so-called modern art of America."[10] Even as those in the art world were eagerly embracing the new abstraction, hailing Pollock as an exemplar of native genius, mainstream America was angrily rejecting what it saw as a dangerously foreign brand of art.

In response to this sort of virulence, and in a preemptive strike against further such criticism, the magazine *Art Digest* published a manifesto, slightly before the Irascibles' protest, that attempted to position abstract art on the side of democracy and freedom: "We recognize the humanistic value of abstract art, as an expression of thought and emotion and the basic human aspirations toward freedom and order. In these ways modern art contributes to the dignity of man."[11]

The very fact that the Museum of Modern Art, the Institute of Contemporary Art in Boston, and the Whitney Museum of American Art, which together issued this statement, should have felt the need to defend abstract art in such explicitly political terms attests to the increasing pressure to affirm "American values," and the increasing suspicion of anything that might not fall in line with those values, that would burgeon into virulent McCarthyism a few years later. But it also prefigures what became the great argument for abstract art, one that in its own way served as a political tool when, a few years later, the American government began exporting

it abroad as part of its cultural program designed to win favor in the rest of the world: that it transcended nationalism to offer a truly international, universal style.

* * *

In the summer of 1950, *Art News* sent the photographer Rudy Burckhardt and the painter and critic Robert Goodnough to Pollock's studio, for a proposed feature to be called "Pollock Paints a Picture." But though Pollock had agreed to allow himself to be photographed in the process of painting, when the two journalists arrived he refused; instead, he told them, he would just *pretend* to be painting. He was much preoccupied with a huge canvas spread out on the floor—the largest painting he had done since the mural for Guggenheim—one in which he had eliminated all color and used only black. The photographer shot him kneeling over the painting and touching it with a dry brush, and the photographs duly appeared in *Art News.*

There are those—among them Pollock himself—who regard the painting Burckhardt photographed that day as one of the great accomplishments of his career. Called *Number 32, 1950,* it was almost nine feet high and fifteen feet long. Yet it consisted of nothing but black lines on canvas.

As his biographer Deborah Solomon describes it, "*Number 32, 1950* shows him at the height of his powers, capable of creating not just a mural but a great work of art with the aid of nothing more elaborate than a naked black line. No form, no color, just line. He can do whatever he wants with it, tapering it into filigreelike delicacy or thickening it until it is heavy as mud. He can make it tauten, slacken, halt, plunge, soar, race, and fly, and reinvent it inch by inch."[12]

The *Art News* photographer had been content to allow Pollock

to mime the process of making a painting rather than actually paint one for the camera. Similarly, Pollock's photographer friend Herbert Matter had considered asking Pollock if he could film him in the act of painting but decided it would be too difficult for him. The next photographer to arrive on the scene was more persistent. Hans Namuth, German by birth, the anti-Fascist son of a Nazi father, had served as a press photographer during the Spanish Civil War of the late thirties; allied with the anarchists against both the Fascists and the Stalinists, he narrowly escaped with his life. After a period in Paris he sought refuge in America, where he served in Army Intelligence during the war. He then became a photographer for *Harper's Bazaar*.

In July 1950 Namuth, who was spending the summer nearby, met Pollock at an art opening and asked permission to photograph him at work. As with the photographer from *Art News*, Pollock assented to the idea when Namuth phoned to make an appointment but was reluctant to go through with it when the other man showed up at his studio. The painting he'd been going to work on during their session was already finished, he said. But when Namuth asked if he could come inside anyway, just to have a look, Pollock changed his mind; he picked up a brush and began hurling paint at the canvas on the floor. In Namuth's own words: "His movements, slow at first, gradually became faster and more dance-like as he flung black, white and rust-colored paint onto the canvas. . . . It was great drama: the flame of explosion when the paint hit the canvas; the dance-like movement; the eyes tormented before knowing when to strike next: the tension; then the explosion again. My hands were trembling."[13]

Namuth shot roll after roll of film and brought the photographs back for Pollock to look at. Pleased with what he saw, Pollock let him return and take more. After that, Namuth came almost every weekend throughout the summer to shoot Pollock at work. Sometimes he shot him from eye level, sometimes from the top of a ladder,

sometimes leaning into an opening in the studio roof from a position on the roof of an adjacent shed.

Remarkably, the paintings Pollock made in the studio that summer, with Namuth clicking away, are some of his most exciting works. In the painting that has come to be known as *Autumn Rhythm*, now in the Metropolitan Museum of Art—a vast, seventeen-foot-long canvas executed in sinuously flowing lines and whorls of black and white, with tiny patches of blue and thick jagged strokes of pallid ocher—he achieved an almost miraculous totality: no area of the painting can possibly be divorced from the whole to be considered separately. Despite its very limited palette, and the dominance of black, it also feels strangely exultant. One of the most lyrical and elegiac of Pollock's paintings, it is at the same time among the most dynamic, perhaps the ultimate embodiment in paint of the dance-like process by which it was created.

By the end of August, Namuth had hundreds of black-and-white images of Pollock painting in the studio—leaning over the canvas, striding around it, kneeling beside it; paint can in one hand, brush or stick in the other. The sense of movement that Namuth captured in these still photographs is remarkable—movement possessed of both extraordinary energy and extraordinary grace. Absorbed in his process, taken over by it, Pollock seems incapable of a false or clumsy move. The scowling, brooding figure he presents in photographs taken of him at rest is transformed; even the habitual frown lines in his forehead are smoothed out. These are images of freedom, of exultation, in almost the same way that the paintings themselves are. In some of them, he looks as though he's literally dancing.

But Namuth was still not entirely satisfied. Quite apart from the fact that he was unable to depict both the painter and the painting satisfactorily in a single shot, from a single angle, no still photograph can entirely capture the feeling of movement. Besides, Pol-

lock sometimes moved so swiftly that the images were blurred. Just before Labor Day, Namuth proposed that he make a film.

A film of an artist applying paint, with brushes, to a canvas resting on an easel could be of great interest to someone curious about the particular painter's process; there might be excitement in witnessing a mastery of technique, as, say, if the painter executes a shape in a single brushstroke. But it will not be a dramatic spectacle; the painter will mostly be standing still, or moving back to check the effect of what has just been done. Pollock in motion around the canvas, hurling and flinging paint, was something altogether different.

At first, Namuth made a brief black-and-white film; subsequently, over a period of several weekends, he shot a longer one in color, with Pollock's full cooperation, even to the extent of repeating actions when Namuth asked him and positioning himself where Namuth could shoot him from the angle he wanted. He tossed aside his cigarette when Namuth wanted to film that particular gesture; later, he signed his name over and over so that Namuth could get a good shot of him in the act. Namuth, however, was still disappointed in the result: as with the still photographs, the problem was that he could not show both Pollock's face and the canvas he was working on in the same frame. It was then that he had the idea of asking Pollock to paint on a raised sheet of glass, so that he could shoot him from beneath and capture both the painting and the painter.

They got a special piece of shatterproof glass. Pollock placed it on sawhorse-like supports and stood on a scaffold he had built. Namuth took up his position underneath, crawling around as he aimed his camera upwards. The wind blew the paint around; Pollock had to keep starting over. As with most films, it was a process of starting and stopping, starting and stopping; whatever rhythm he usually got into while painting was disrupted.

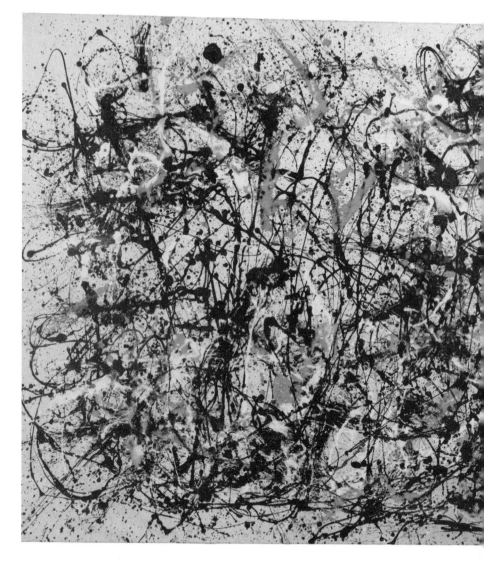

Autumn Rhythm: Number 30, 1950. 8 ft. 10 1/2 in. × 17 ft. 8 in. © 2011 The
Pollock-Krasner Foundation / Artists Rights Society, New York. Reprinted by
permission of the Metropolitan Museum of Art / Art Resource, NY.

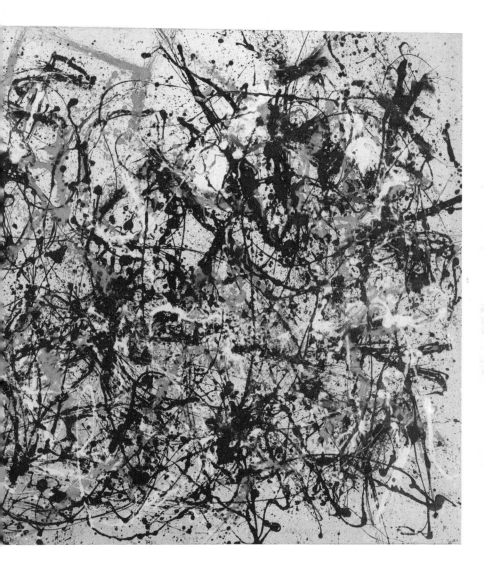

This went on over a period of weeks. Finally, late one afternoon towards the end of November, having captured Pollock applying not only paint but sand, pebbles, and other miscellaneous materials to the glass painting, Namuth announced that they were done; he'd gotten all the shots he needed. Krasner had planned a dinner party that night, a belated Thanksgiving celebration and a party to mark the end of the filming. Pollock, who had been sober for two years, marched into the house and poured himself a drink.

Chapter Seven

The events of the summer and autumn of 1950 were to have far-reaching consequences that could not have been imagined at the time. The Namuth films, and the still photographs he took in the studio, not only remain the most powerful and charismatic images of Pollock we have; they are also the single most important factor in shaping and disseminating his legend.

"You cannot imagine the impact these photographs, as distinct from the paintings, had on artists world-wide when they were first published in the fifties," Kirk Varnedoe told a television interviewer. "To see a man making art like this . . . to see him standing into his canvas . . . to see him throwing down paint was so radical that the pictures had a huge impact on the popular imagination of Pollock."[1]

Pepe Karmel wrote in the catalogue for the Pollock exhibition at MoMA in 1998, "It seems impossible, in retrospect, to distinguish the objective Pollock from the mythic Pollock who was, in a sense, created by Namuth's photographs."[2] Indeed, these photographs have

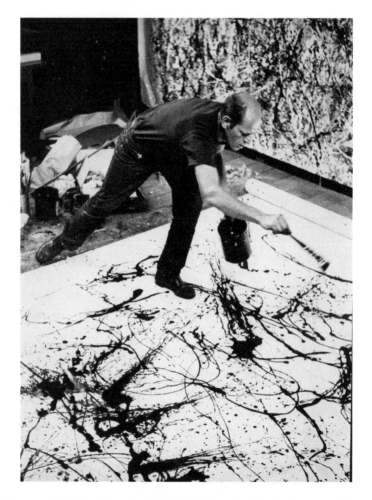

Photograph by Hans Namuth of Pollock in his studio. Reprinted courtesy Center for Creative Photography, University of Arizona © 1991 Hans Namuth Estate.

themselves become the object of intensive analysis, scrutiny, and commentary by art critics, whose theories about Pollock's work have often relied heavily on the evidence of his working processes as provided by Namuth.

The Pollock whom Namuth presented to the world was a shaman figure, charged with uncanny force, engaged in a ritual dance in which the man and the painting became one, just as all the disparate elements within the painting coalesce into a unified whole. This figure is likewise conjured up by a seminal article Harold Rosenberg wrote for *Art News* in 1952, in which he declared that "at a certain moment the canvas began to appear to one American painter after another as an arena in which to act—rather than as a space in which to reproduce." For the "American action painters" of his title, "what was to go on the canvas was not a picture but an event," and "since the painter has become an actor, the spectator has to think in a vocabulary of action."[3]

Though it has been contended that Rosenberg was actually thinking of de Kooning when he wrote those words, for most people, they brought Pollock to mind. And this notion of art as an event, specifically in conjunction with the Namuth photographs, would have implications as revolutionary as those attending Marcel Duchamp's exhibition of a urinal at the Armory Show of 1913. Namuth's images had an enormous influence—arguably greater than the drip paintings themselves—on the art that came after Pollock.

As early as the 1950s, the Japanese Gutai artists were engaging in body art performances that were inspired by the photographs and films of Pollock painting. By the late sixties, the focus of interest among artists around the world was not the style of Pollock's work but the behavior that produced it. In New York, Allan Kaprow, the father of the happening, declared himself to be the true successor to Pollock, and he was widely seen as such. Kaprow's view was that while Pollock had destroyed painting by taking it as far as it could go, at the same time he had provided art with its new direction. He hailed Pollock's dance around the canvas, his flinging and hurling of paint, for blurring the old distinction between art and life and showing artists the way forward:

[Pollock] left us at the point where we must become preoccupied with and even dazzled by the space and objects of our everyday life, either our bodies, clothes, rooms, or, if need be, the vastness of Forty-second Street. Not satisfied with the suggestion through paint of our other senses, we shall utilize the specific substances of sight, sounds, movements, people, odors, touch. Objects of every sort are materials for the new art: paint, chairs, food, electric and neon lights, smoke, water, old socks, a dog, movies, a thousand other things that will be discovered by the present generation of artists. Not only will these bold creators show us, as if for the first time, the world we have always had about us but ignored, but they will disclose entirely unheard-of happenings and events, found in garbage cans, police files, hotel lobbies; seen in store windows and on the streets . . . an odor of crushed strawberries, a letter from a friend, a billboard selling Drano."[4]

From the vantage points of conceptual art and post-minimal sculpture, what mattered was that Pollock had reinvented the relationship between painting and all other activities. With a boost from the playful spirit of Fluxus and a Dada-rooted lineage of aggressive performance, artists in Vienna, Tokyo, and elsewhere enlisted Pollock's authority to turn their attention from what art looked like to the manner of its production. Art was a residue of performance, and of a larger but less visible system of production and consumption, which the individual artist confronted in his or her own way. It was the style of confrontation that defined the artist— the "actor"—as once the style of painting had done.

But the idea of the painter as actor, which for Rosenberg was an existentialist construct, has a double meaning in the context of Namuth's undertaking. Pollock was not only the actor precipitating the event taking place on the canvas; he was also, literally, acting for

Namuth's cameras. Namuth was the director; Pollock had to move where and when Namuth told him to, stop when Namuth told him to stop, start up again at Namuth's command, repeat the same actions over and over. He was not so much an action painter in Rosenberg's sense but an actor playing a painter, Jackson Pollock impersonating himself.

Once he started drinking that afternoon in November, he reverted to his most aggressive, most angry drunken persona, shouting insults at Namuth and, later that evening, while the assembled dinner guests looked on in horror, overturning the dining room table laden with the food that Krasner had prepared. ("Coffee will be served in the living room," Krasner said, as smashed crockery and the twelve turkey dinners it had held lay strewn around the floor.) Right before he upended the table, as he stood there clutching it with both hands, he kept insistently asking Namuth if he should "do it now," in mockery of those long hours when Namuth, behind the camera, had given Pollock directions about what to do when.[5] Prior to that, he had been hissing drunkenly at Namuth, over and over, that he wasn't a phony, that it was Namuth who was the phony.

Pollock's years of sobriety had been the most productive, and probably the happiest, of his life, the period when he made his greatest paintings. After the night when he took up drinking again, he never entirely recovered either his sobriety or his artistic equilibrium. Other factors were at work: the doctor who had helped him quit drinking had died in a car crash several months before; he was under enormous pressure to do something new that would reinforce his position as "the strongest painter of his generation." Maybe he felt he had gone as far as he could with the drip paintings, and had no clear idea of what direction to take his work in next; maybe he was afraid he could only start repeating himself, with less and less spectacular results. Nevertheless, the fact that his sobriety ended on the very day Namuth finished filming is highly suggestive.

Namuth's interest in filming him in the act of painting was itself a sign of the celebrity he had achieved, a flattering token of his success. But allowing Namuth to film what had previously been a deeply private, solitary activity, and to direct and control that activity, was a collusion with the machinery of celebrity, the idea of stardom, that was bound to arouse ambivalence. Pollock craved success and the trappings of success; having been poor all his life, when his show at the Betty Parsons Gallery finally enabled him to buy more than basic necessities for the first time, he went on an all-American spree of buying and home improvement. He had central heating installed throughout the house in Springs, and an expensive carpet laid in the living room; he ate a lot of steak and bought himself several elegant suits and tweed sports jackets. A while later, he traded in his battered Model A Ford for an equally battered but infinitely more glamorous Cadillac convertible.

At a family reunion he had hosted in Springs shortly before Namuth started filming him, he was eager to show off his newfound prosperity and fame to his mother and his still struggling brothers. He even made them all look at an article in Italian—which none of them, including Pollock himself, understood—because he saw that the Italian critic seemed to be comparing his work in the American pavilion of the Venice Biennale to Picasso, the man he had wanted to best all his life. (As he would find out later, the critic was saying that he made Picasso look like "a quiet conformist, a painter of the past.")[6]

But competitive as he was—with his brothers, with Picasso, with the other artists he knew in New York—it was never a simple matter of glorying in his fame. As a member of a generation of artists who had grown up poor, lived through the Depression, and taken up leftist causes, and who saw art as a spiritual calling, it would never be possible for him to embrace that kind of celebrity wholeheartedly. His uneasy relationship with his own success, and his doubts about its validity, continued for the rest of his life.

Ever since the *Life* article appeared, Pollock had increasingly been besieged by admirers and curiosity seekers, some of whom showed up at his house in Springs unannounced. According to Clement Greenberg, rather than being thrilled by the attention he thought he wanted, "he looked like he wanted to crawl into a corner somewhere."[7]

His first biographer, B. J. Friedman, who became a friend of Pollock's and an early collector of his work, also remembered his experience of fame as being largely negative, a matter of having become a commercial object, which he could not accept or cope with. "I think he just couldn't withstand it or couldn't fight it," said his friend and fellow artist James Brooks.[8]

If not the first artist in history to become fodder for the fashion magazines and the gossip columns, to be turned into a commodity and devoured as such, he was at least the first of the Abstract Expressionists to receive such treatment. After his death, fame and even vast wealth would come to several others among them, and none of them dealt with their success particularly well. Of course they were tempted by the prospect of attaining a level of comfort and security after years of grueling hardship—not to mention that their egos demanded they not be outstripped by their erstwhile brethren in struggle. Unfortunately, their feelings about purity made them awkward candidates for the fame and riches they sought. Unlike the generation of artists after them, who seemed cheerfully unconflicted about enjoying the fruits of their success, they had defined themselves in terms of heroic opposition to the commercial, Philistine culture that spurned them. Then, compounding their difficulties, it began tempting them to accept its acclaim. If, as William James said, the "worship of the bitch-goddess Success is our national disease," he was probably also right when he wrote, "Need and struggle are what excite and inspire us; our hour of triumph is what brings the void."[9]

The richer and more famous Rothko, for example, became, the more his depression and his doubts about his work deepened; as we have seen, he regarded art as a spiritual activity, and his own paintings as manifestations of religious feeling. Yet they were being bought for vast sums and commissioned to decorate elegant restaurants; he could no longer be sure either that they were truly great or that they were valued for the right reasons. In 1970, at the height of his fame, he slit his wrists and bled to death. Ironically, the autopsy showed that he had also taken an overdose of the antidepressants prescribed to pull him out of his despair.

De Kooning managed things a bit better, but happiness eluded him too. Though, like Pollock, he flaunted his success when it came, he was never entirely comfortable with it, nor with the idea of equating the activity of painting with a monetary return. His instinct was to get rid of his money as fast as he could, until there was too much of it to make that practical. And it is notable that he too descended into depression and heavy drinking once he achieved great fame. ("I could not bear to live——aloud—— / The Racket shamed me so," Emily Dickinson wrote.)[10]

Interestingly, of all the Abstract Expressionists, the one who dealt most successfully with the attentions of the art world, and the world at large, was probably Clyfford Still, who was also the one Pollock admired most and felt closest to—the only one to whom, and about whom, he never said anything derogatory. Pollock has sometimes been called the leader of the Abstract Expressionists, but that is a misleading designation. For one thing, they were always a very loosely connected group of artists, not a formal movement; they had no leader in the sense that André Breton was the acknowledged "Pope" of the Surrealists. For another, Pollock's relationships with most of them were never purely friendly, in the way that some of the relationships between the others were.

In particular, he was fiercely competitive with de Kooning, who

became a neighbor of his on Long Island. De Kooning, whose painting retained more figurative elements, and more rigorously formal ones, than Pollock's, was Harold Rosenberg's exemplary avant-garde painter, as Pollock was Greenberg's. Many of the artists, too, admired his work more than they did Pollock's. Yet Pollock was capable of showing generosity even to his archrival, as when he made a point of taking Ossorio to de Kooning's studio, knowing that Ossorio was likely to buy a painting, which he did.

Nevertheless, Pollock was prone to sneering at de Kooning's work, and to insulting him personally, as he did with most of the other painters in their circle. Still was the one exception. Like Pollock, Still was a westerner; like Pollock, he had long been interested in Native American art; like Pollock, he was a genuine radical in his art—his signature paintings featured huge, jagged, dramatic flame shapes, thickly impastoed and as fierce as the man himself. In an interview with the critic Irving Sandler, de Kooning attributed the expansiveness of Pollock's and Still's paintings to their Americanness; he himself, he said, with his European background, was essentially "conservative," while Still and Pollock "eat John Brown's body. They stand all alone in the wilderness—breast bared. This is an American idea. . . . I feel myself more in tradition."[11]

Still was also like Pollock in that he was anything but a joiner. Thus, when a group of painters including de Kooning formed what they called the Club, which became a thriving center of intellectual and social life for the downtown painters, critics, and curators during the fifties, Pollock and Still were rarely in attendance. They were the two resolute loners of the Abstract Expressionists.

But Still's most salient characteristic, and the quality that may have enabled him to survive better than Rothko or Pollock or de Kooning, was his fanatical moral righteousness. Despite his origins in North Dakota, he more closely resembled a seventeenth-century Puritan divine than a frontiersman, and one engaged in an un-

relenting battle with Satan. His vehement moral stance about art and the art world, which he saw as a veritable sea of corruption, makes his correspondence read like a collection of thunderous sermons. Continually outraged by others' failure to live up to his high ethical standards, he clearly felt it his bounden duty to point out their shortcomings, though without holding out much hope that they would reform. Thus, he castigated his correspondents—artists, dealers, critics, former students—for their moral turpitude.

Such was Still's general disgust with the art world that he refused to sell the vast majority of his paintings during his lifetime, and when he permitted a collector to buy one, he required that it be hung on its own, in a room with no other paintings in it. In his will, he stipulated that the works still in his possession could be shown only when a museum housing the entire collection had been built to his specifications, with the proviso that nothing ever be sold or given away. His monomaniacal, sometimes brutal insistence on maintaining his purity—while excoriating others for their lack of it—did not make him popular, and he never achieved the huge fame of some of his contemporaries. But he never experienced the kind of misery they did, either. He found enough admirers who would accept his terms to keep him solvent, and he went on working to the end. Refusing to become what he called "a baubled court jester" or "a spaniel for old ladies," he retained both his own version of sanity and his pride in his incorruptibility to the last.[12]

Given Still's low opinion of almost all his fellow artists, his high regard for Pollock, while it lasted, was particularly gratifying. In the early fifties, after seeing a group of Pollock's paintings, Still wrote him that "the great thing, to me . . . was that here a man had been at work, at the profoundest work a man can do, facing up to what he is and aspires to."[13]

Chapter Eight

Ironically, despite Pollock's growing fame and cachet, the financial success of his November 1949 show was not repeated in 1950. Just a few days after the explosive scene with Namuth, the opening of his fourth solo show at the Betty Parsons Gallery was packed with people from a more fashionable set than had ever evinced interest in him before, many of whom were more eager to get a view of the notorious painter than to look at his paintings. (One friend from Long Island likened his position to that of an exotic animal in a zoo.) In the days and nights that followed, he reverted to his old habits, going from bar to bar in the Village, drunk and miserable. But though the show contained some of his greatest work, it sold poorly, with the main sale, of *Lavender Mist*, being to Ossorio. A few months later, *Lavender Mist* was featured in a spread in *Vogue*, the backdrop for an evening-gown-clad model in a photograph by the glamorous photographer Cecil Beaton. Yet even this ultimate mainstream endorsement, this sell-out to the glittering world of fashion, did not stimulate sales.

In November 1951, Parsons had a similar lack of success sell-
ing the monochrome black paintings he showed at her gallery, in
which figurative elements once again appeared. Applied with a tur-
key baster on an unprimed surface, the black enamel soaked and
bled into the canvas, creating subtle variations in texture. Green-
berg, though he was always regarded as a purist about abstract art,
was one of the few vocal admirers of the black paintings: "His most
recent show, at Parsons," he wrote, "reveals a turn but not a sharp
change of direction; there is a kind of relaxation, but the outcome
is a newer and loftier triumph."[1]

The delicately controlled draftsmanship on display should have
won over those who had dismissed Pollock as undisciplined, but
the images that emerged from the skeins of black paint (severed
heads, mutilated limbs) were too violent to be immediately appeal-
ing to the audience for art at that time. Whether or not these paint-
ings are indicative of an obsession with death, as some critics have
claimed, they are definitely disturbing. They found no favor with
collectors: only two of them sold, at what Pollock felt were insult-
ingly low prices. He was suffering all the unwelcome attention and
even humiliations of fame—*Time* magazine never stopped its jeering
attacks on him and the "chaos" it claimed his work represented—
with none of the material benefits. A show in Paris that Ossorio
arranged for him proved to be an economic disaster, yielding no
profits at all; though his fame was spreading to Europe, he was slip-
ping back into near-poverty once again.

And he was still drinking, despite the efforts of Krasner's homeo-
pathic physician to return him to sobriety, and the ministrations of
a chemist the homeopath recommended who promised results with
a potion containing such elements as guano.

Believing that it was Parsons's well-known lack of business savvy
that was responsible for his disappointing sales, Pollock signed up
with Sidney Janis, Parsons's polar opposite when it came to promot-

ing artists. Janis was famous for his shrewd marketing strategies and his willingness to spend money in order to make it; he already represented Mondrian and Kandinsky, and his focus, unlike Parsons's, was very much on selling.

Yet even Janis could not sell the paintings Pollock showed with him in early 1952, apart from one small work that netted Pollock all of a thousand dollars. Now that the novelty of his work had worn off, collectors seemed to be losing interest fast. And to compound his sense of failure, it was the first show of his that Clement Greenberg did not review. According to Greenberg, he was doing Pollock a kindness by not expressing the disappointment he felt about these paintings. Pollock himself, Greenberg said, was not offended by his silence, in itself a bad sign: he may have agreed with Greenberg about the weakness of the new work.

One of the paintings in the Janis show of 1952 became the center of a controversy twenty years later: namely, was it Pollock's work alone, or the product of a collaboration between him and several other (drunken) artists?

Number 11, 1952, more commonly known as *Blue Poles*, has been hailed by some critics as one of Pollock's supreme achievements, maybe even *the* supreme achievement of his life. The poet Frank O'Hara, for example, called it "one of the great masterpieces of Western Art. . . . *Blue Poles* is our *Raft of the Medusa* and our *Embarkation for Cytherea* in one. I say *our*, because it is the drama of an American conscience, lavish, bountiful and rigid. It contains everything within itself."[2]

One thing it contains, as its name suggests, is a series of tilting verticals which, though blurred and spindly, lend this otherwise classic drip painting a structural element more characteristic of Pollock's much earlier work. Some have likened these poles to "zips," as Barnett Newman called the narrow bands that separated fields of different color and, as he saw it, animated the surface in his own

paintings. Newman was said to have participated in the creation of *Blue Poles*, although he later denied it.

According to Tony Smith, a painter friend of Pollock's, what really happened was that Smith visited Pollock in his studio at a time when Pollock was having trouble forcing himself to work and suggested that they do a painting together. Both of them were drunk at the time, and what they produced looked, as Smith said, "like vomit." Several weeks later, Smith brought Newman over, and Newman, too, in order to get Pollock working, added to the painting, following Pollock's example by squeezing paint directly onto the canvas from the tube. It was over the mess that the three men had made that Pollock eventually painted what came to be known as *Blue Poles*.

Greenberg is one of the few critics who regarded the painting as a failure, perhaps feeling that the "poles" had been added to lend tension and focus to what otherwise was not one of the most coherent drip paintings. Many others, at least among those who wrote about it after Pollock's death, were, like O'Hara, rapturous in their praise, hailing it as a masterpiece, even as Pollock's supreme artistic achievement: a dazzling summing-up of the work of his greatest period.

But if it was a summing-up, it was also a kind of swan song. In 1950, Pollock's annus mirabilis—and the last year of his sobriety— he had produced more than fifty paintings. In 1954, he completed exactly one. In 1955, it was two. In these, the final works of his we have, he returned to the less radical technique he had used right before he began pouring paint. *Scent*, his last successful work, has a gentle, contemplative feel to it, and a very tactile quality. It is thickly impastoed, densely composed, more richly and sweetly colored than the drip paintings; interestingly, given his state of depression, white predominates over black for the first time in his work. While not

one of his greatest paintings, it at least suggests that he might have gone on to do further extraordinary things.

By 1956, he seems to have stopped painting entirely; either that, or he destroyed any work he made. Nothing has survived. He started drinking shortly after he got up in the morning; by noon he was generally drunk, and he stayed drunk until he passed out wherever he happened to be, sometimes at home, sometimes on the street or in his car or at a friend's house. There was no form of clichéd drunken behavior he didn't go in for in these years: he veered from maudlin self-pity to belligerent insults to grandiose boasting. He might sob that he was finished, or that he was no good, and then drive to Harold Rosenberg's house in Springs to scream at the darkened windows that he was the greatest painter in the world.

Yet even during this period, or perhaps particularly during this period, when his own misery may have made him more sensitive to other people's distress, he was capable of great kindness at times. While some of his neighbors in Springs remembered dreading his visits so much that they turned out their lights and pretended they weren't home when they heard his car, others recalled his sweetness and generosity. He would give his work away to people who admired but couldn't afford it. "The number of friends who were given works is legion," one of his neighbors in East Hampton remembered. He would also help people out with repairs, or just provide sympathy. According to another of his neighbors on Long Island, "It was more than kindness with Jackson: if you were in trouble, or he was with children, he would be as gentle and lovely as a mother. And he kept confidences, no matter how drunk."[3] (It seems worth noting that the speaker here is a woman, since so many women complained of his aggressive sexual advances to them when he was drunk—advances that nobody seriously believed he wanted to be taken up on.)

For a time, he still went to his studio every day, but after weeks and then months of not producing anything, he could no longer bring himself to stay there for very long. Instead, he would go out and find someone to fight with, sometimes playfully, sometimes not. In 1954, having challenged a reluctant de Kooning to a wrestling match, he began sparring with himself on de Kooning's lawn and broke his ankle. Eight months later, when the ankle had healed and he had found someone else to wrestle with, he broke it again.

Meanwhile, despite himself, his fame was growing. His work was included in group shows at the Whitney and the Guggenheim in New York and in other museums across the country; he had four paintings in an exhibition of contemporary American art, organized by the Museum of Modern Art, that traveled to Paris, Zurich, and several Scandinavian cities. His 1954 show at the Sidney Janis Gallery was more respectfully received than ever, although it was full of unresolved work, paintings that indicate the confusion he was feeling about which direction to take. *Portrait and a Dream* is a brave but not entirely successful experiment: half of it is like a replica of one of his black-and-white paintings, while the other half contains a partially "veiled" self-portrait in garish color and in a style reminiscent of the Surrealist-influenced work of his first show with Guggenheim. Another painting with figurative elements, *Easter and the Totem*, bears a certain formal resemblance to the collage paintings Krasner was doing in the upstairs bedroom that she had taken over when Pollock moved into his studio. Still another work, *The Deep*, is possibly the prettiest painting that Pollock had ever made, but veers perilously close to kitsch.

The *New York Times* reviewer praised these canvases as "a happy advance over the impersonality of much of his early work." The *Herald Tribune* hailed "a new and promising approach. To begin with, they're really painted, not dripped!"[4] Obviously, it was a great relief to many that Pollock was making recognizable paintings again.

But one voice was conspicuously absent from the chorus of praise. For the second time, Clement Greenberg refrained from reviewing a Pollock show, a clear signal that he was losing enthusiasm for the work. When his silence was broken, in the spring of 1955, Pollock cannot have been pleased with what he read: "His most recent show, in 1954, was the first to contain pictures that were forced, pumped, dressed up, but it got more acceptance than any of his previous exhibitions had—for one thing, because it made clear what an accomplished craftsman he had become, and how pleasingly he could use color now that he was not sure of what he wanted to say with it."[5]

In another essay he published that spring, Greenberg praised the work of Still, who, he said, had "liberated . . . abstract painting, as Pollock had not, from the quasi-geometrical, fairy drawing which Cubism had found to be the surest way to prevent the edges of forms from breaking through a picture surface." He also hailed Still as "perhaps the most original of all painters under fifty-five, if not the best."[6]

Sidney Janis, at any rate, was not much affected by Greenberg's defection. He proposed mounting a retrospective of Pollock's work at the end of 1955, an idea that, however flattering, must have been a little depressing for Pollock, too, suggesting as it did a certain finality. If he had not already felt that his career as an artist was over, it might have pleased him more.

* * *

In the summer of 1955, Pollock spoke of going to Europe— something he had often declared he wouldn't do, didn't need to do, mocking other artists who went rushing there to worship at the shrine, deriding "the old shit (that you can't paint in America)."[7] He even applied for a passport, but he never signed it. He

was perpetually enraged with Krasner, who, pitifully, kept trying to get hot drinks and hot food and vitamins down him, while he shouted insults and obscenities at her and may have been physically violent too. Sometimes, she shouted back—she was not really the saintly type—but there are also accounts of her showing a heartbreaking solicitude for the wreck he had become. Where once she had been scornfully silent and tried to ignore him when he was taunting and mocking her, now, it seems, he was so clearly in torment that she could no longer even blame him for acting as he did. At times, at least, she could only pity him and try to offer comfort. At other times, she threatened to have him locked up, in either a mental hospital or a jail.

That same summer, he went into therapy again, this time with a young clinical psychologist, and made weekly trips into Manhattan for his sessions. Afterwards, he would go to the Cedar Tavern, a Greenwich Village bar on University Place at 11th Street where downtown artists had been hanging out since the forties.

People began going there just to catch a glimpse of him. He had become a celebrity in the art world and beyond, the equivalent of a pop star today, and as with a pop star, his misbehavior only added to his celebrity. He was a tourist attraction for people from the outer boroughs who wanted to experience the thrill of watching him misbehave, though sometimes they got more than they'd bargained for. It was on Monday that he had his appointments with his therapist. On Monday evenings, aspiring artists waited expectantly in the Cedar for him to show up. They greeted him by name, fell over themselves to buy him a drink, touched him to bring themselves luck. The tourists, more interested in seeing him smash the place up than in paying their respects to a modern master, waited for him to create one of the scenes he was famous for. And, tragically, he gave them what they wanted, attacking doors, walls, people. The great action painter, who was not painting any more, was performing

as the villain in the western, swaggering into the bar and creating mayhem. At least once, he pulled the same trick that had ended the dinner party at his house on the day Namuth completed filming: he swept the contents of a table where a couple was eating dinner onto the floor.

Just a few blocks west, and a few years earlier, a similar scene had been played out, with admirers and hangers-on trying to get a drunk a little drunker and then watching to see what outrageous thing he would do or say. That other drunk was a poet, the Welsh-born Dylan Thomas, who, like Pollock, became a romantic legend as much for his alcoholic bad behavior as for his rhapsodic work. Though Thomas was never physically violent in the manner of Pollock, he too became a spectacle in the Greenwich Village of the fifties, and the place where he drank—the White Horse Tavern, at 11th Street and Hudson—became, like the Cedar, a tourist attraction for the bohemian and quasi-bohemian set. As one writer remembered, "People would be eight deep at the bar, all because Dylan Thomas was there."[8] The table where, it was said, Thomas had his final drink before collapsing—he died at St. Vincent's Hospital a few days later—was pointed out proudly to new customers; a plaque was even erected on the wall next to it.

It seems there is something particularly thrilling about watching an artist destroy himself; the buttoned-down can watch the unbuttoned act out their aggressive and nihilistic urges, while the cachet of the other's fame lends the spectacle a special excitement. Both Pollock and Thomas came to messy ends, destroying themselves at a young age. It's hard not to conclude that that was what those denizens of the Cedar and the White Horse were secretly hoping for: after all, the romantic idea of the genius, particularly the male genius, is of a wild, self-destructive, larger-than-life figure, someone to be revered and envied for his boldness and freedom and yet also made to serve as a cautionary tale. Witnessing his

disintegration affords not only the voyeuristic frisson that comes from feeling one is seeing his most essential, naked self revealed— and is therefore achieving a kind of intimacy with him, even taking possession of him, in a way no other circumstances would allow— but also a slightly vengeful emotional gratification. As Freud pointed out, along with the veneration accorded "the privileged person"— someone permitted to break taboos—"there is the unconscious opposing current of intense hostility."[9]

The frisson experienced by the habitués of the Cedar may have been especially keen because of the general atmosphere of the period. Seldom has there been such intense pressure to conform, not just politically but socially and even psychologically, as there was in America in the fifties. Dylan Thomas described it as "an enormous façade of speed and efficiency and power behind which millions of little individuals are wrestling, in vain, with their own anxieties . . . there seems to be no reality at all in the life here,"[10] while the sociologist David Riesman, in his 1950 book *The Lonely Crowd*, asserted that the "other-directed" person had become the dominant type in American society. Other-directed people were primarily concerned to do, think, believe, feel, and consume the way those around them did, which made them the ideal target for advertisers. They wanted to fit in, to be esteemed and accepted by others, and to enjoy material prosperity—three goals that were not entirely unrelated.

Optimism was virtually a patriotic requirement. Norman Vincent Peale's *The Power of Positive Thinking*, which proselytized for a can-do attitude and enjoined people to banish dread and doubt from their minds, was on the best-seller lists for more than three years, and for two of those years was second only to the Bible in sales. Peale, a Protestant minister, offered a faith-based prescription for mental health that was very much in keeping with the ethos of the times, in which religion and patriotism were intertwined: the righteousness of a godly America versus the evils of godless Com-

munism was an article of faith. It was in the fifties that "under God" was first added to the Pledge of Allegiance to the American flag, and American currency began to bear the legend "In God we trust." At the same time, there were calls to withdraw books about Robin Hood from school libraries, because Robin's practice of robbing the rich to give to the poor smacked of Communism, which made it displeasing to God.

To express doubt about the superiority of the American way of life and the beliefs of the American majority could lead to social and professional ostracism. During the witch hunt of the mid-fifties, when the megalomaniac Senator McCarthy of Wisconsin was intent on purging Communists and suspected Communists from the government and various other walks of American life, the innocent were punished along with the guilty. Even for those who were not jailed or publically disgraced, the mere fact of coming under suspicion could destroy their lives by making it impossible for them to practice their profession. Any deviation from majority opinion— any suggestion that America, too, had its problems, even to the extent of criticizing the Jim Crow laws and discriminatory voting practices that blatantly deprived blacks of their constitutional rights—was regarded as Communist-influenced and could have serious consequences.

The most approved and popular artist of the time was Norman Rockwell, whose sentimental paintings and hundreds of magazine covers for the *Saturday Evening Post* celebrated the cozy innocence of small-town America and the joys of American family life. Grandmother places the Thanksgiving turkey on the table around which the whole smiling family is assembled; an elementary school teacher beams lovingly at the shiny-clean children in her classroom; Boy Scouts stand to attention; a tousle-headed little boy in patched overalls gazes at the harvest moon with his arm around a little girl in pigtails, while their adorable puppy stares out at the viewer. One

would never suspect from looking at Rockwell's work that he was married three times, his second wife had a nervous breakdown, and he himself received treatment at the Austen Riggs psychiatric facility for his emotional difficulties.

Yet at the same time that so many people were, in effect, sacrificing their individuality to conform to society's expectations of them, eight of the ten most widely watched shows on television were westerns. It was a genre that celebrated the old, manly virtues of courage and integrity and plain speaking, precisely the qualities that the "organization man," the very essence of the other-directed personality, failed to display. In effect, the western translated the tenets of existentialism, with its emphasis on achieving meaning through the exercise of individual free will, into the language of popular entertainment.

Meanwhile, rebel-figures like James Dean and Marlon Brando, also asserting a troubled independence from the crowd, were superstars—particularly to the younger generation, which was viewed by its elders with increasing alarm, perceived as harboring subversive, antisocial opinions and desires that found expression in "juvenile delinquency." Clearly, something subversive and defiant was working its way towards the surface; mutiny was brewing against the ethos of the age.

Within a year of Pollock's death in 1956, Elvis Presley—"Elvis the Pelvis," widely condemned as indecent for his gyrations on stage—would perform on the Ed Sullivan Show, the most popular variety program on television. Jack Kerouac would publish his novel *On the Road*, the manifesto of the antiestablishment Beat Generation. Allen Ginsberg would come to prominence as the author of *Howl and Other Poems*, a volume including a poem called "America" that contained such lines as "America when will we end the human war? / Go fuck yourself with your atom bomb," and

"Are you going to let your emotional life be run by / Time Magazine?" And just a few years later, Norman Rockwell, the great celebrator of the American way of life, became a tacit critic of its injustices when he began using his skills at folksy propaganda in the service of the civil rights movement.

Chapter Nine

Most of the reviews of Pollock's retrospective were adulatory, but *Time*, in its disdainful article on the show, managed to make even the praise he had received from other critics sound fraudulent. Beginning with a description of how "the bush-bearded heavyweight champion of Abstract Expressionism shuffled into the ring at Manhattan's Sidney Janis Gallery, and flexed his muscles for the crowd," it went on to mock both his work and the reviewers who had acclaimed him: "When it came down to explaining just what Pollock was up to, the critics retreated into a prose that rivaled his own gaudy drippings." The article ended with a quote from *Arts*—admittedly a somewhat silly one—about how Pollock's work was "charged with his personal mythology" and therefore "meaningless to him for whom Pollock himself is not a tangible reality," and then delivered the punch line: "In other words you can't tell very much about the champ without a personal introduction."[1]

Even more shattering for Pollock, who was already deeply depressed, was a blistering letter he received from Clyfford Still in

early 1956. Had Pollock not invited him to his retrospective, Still wanted to know, because he was ashamed of the work he was doing? "Or are you ashamed of what you are willing to take from those who know how to use you to express their contempt for the artist as a man? It's a hell of a price to pay, isn't it?"[2] Still's withering scorn devastated Pollock, who sobbed uncontrollably when he read Still's letter and then proceeded to read it over and over in the next few months. Whatever doubts he felt about his own success, and about the paintings he produced during his period of fame, Still's condemnation brought them to the fore.

Pollock once likened himself to "a clam without a shell." It is a phrase that van Gogh might equally have used to describe his own painful sensitivity, a phrase echoed in the Russian poet Marina Tsvetaeva's characterization of herself as "a person skinned alive, while all the rest of you have armor."[3] But it is a self-description that would also be recognized by many people who have suffered from a tormenting mental illness without being able to convert their suffering into art.

Now even the bravado that had carried him through before, at least some of the time, was dissolving, except on those occasions when he was performing for the denizens of the Cedar Tavern. He was no longer painting. Neither his analyst nor anyone else could alleviate his anguish. He went to see *Waiting for Godot* on three separate occasions and could never bear to sit through it; confronted with his own despair, he either walked out or sobbed so loudly that his companion had to lead him away. But even a bad movie could reduce him to tears.

In the spring of '56, he met a pretty young woman named Ruth Kligman at the Cedar Tavern. Twenty-six to his forty-four, an art student and former model, she had dreamed for a long time of a great romance with a great artist, and when she inquired who the best living artists in America were, she was told that Pollock was

the greatest of them. Perhaps that's why, unlike the other aspiring female artists he'd groped or leered at or propositioned during those evenings after his analytic sessions, she was not put off by his puffy, grizzled face and swollen body or his obvious drunkenness. Instead, after their first meeting, she phoned him to ask if she could see him again; already, in her mind, there was a special connection between them, something preordained.

Others saw the affair that ensued between them a bit differently: as a drowning man's last-ditch effort to stay afloat; as an expression of rage at Krasner; as Pollock's pathetic attempt to prove, to himself and others, that he was a real man. He boasted about her to anyone who would listen, producing her photograph to show how sexy she was; he paraded her around, clearly delighted to be seen with such a nubile, adoring young woman on his arm.

However other people viewed the relationship, Pollock began to pin all his hopes on it, just as Kligman did. He talked, to her and others, about marrying her . . . even if he vaguely imagined that somehow she, he, and Krasner would all live together. Krasner had no such intention. When she came out of the house one morning and saw Pollock and his mistress emerging from his studio, where they had spent the night, she was furious, screaming at Pollock to get Kligman off the property before she phoned the police.

On July 12, Krasner sailed for Europe, making the trip alone on which she'd hoped Pollock might accompany her. When she arrived at the dock she was so troubled at the thought that she was deserting him, and so frightened of what might happen when she did, that she almost changed her mind about going, but finally, after phoning him, she boarded the ship. He immediately moved Ruth Kligman into the house, but it soon became clear that that was no solution. The rage that Pollock had directed at Krasner when Kligman seemed his great hope of happiness—and Krasner the barrier

to that happiness—was now turned on Kligman, who watched her romantic fantasies of a life with him slip away. When he wasn't shouting at her, insulting her, or spurning her efforts to help him, he ignored her; he went on drinking and crying. She had thought, naïvely, that she could teach him to enjoy life, that once they were alone together his despair would evaporate. But that didn't happen. Little more than a week after she moved in with him, he sneaked off to send a dozen red roses to Krasner in Paris.

A despondent Kligman returned to the city, promising to return that weekend. And then there was nobody to look after Pollock, who had never in his life looked after himself. He spent much of the next few days in tears: he cried when a friend of Greenberg's cut his fingernails for him (Krasner had always done that; he didn't know how to do it himself); he cried over the scornful letter Clyfford Still had sent him eight months before; he cried over the death of a stray dog he had found on the road after it had been hit by a car and tried in vain to save.

When Kligman came back, as she'd promised she would, she brought a girlfriend with her, a young woman named Edith Metzger, who would take the last photograph of Jackson Pollock while he was alive. It was Saturday, August 11; Pollock had been invited to a party at Ossorio's elegant house that evening, where a pianist from the New York Philharmonic would be entertaining the guests. Kligman wanted to go; Pollock did not. When he changed his mind, he and the two women piled into his car. He had been drinking for most of the day.

They never arrived at the party. Pollock stopped at a bar to get some food, passed out briefly in the car, and then decided to go home instead. Metzger refused at first to drive with him, but after much coaxing Kligman prevailed on her to get back in the car. With Metzger sobbing and screaming in the back seat, and then trying

desperately to climb out of the speeding Oldsmobile, Pollock, in a rage, put his foot all the way down on the gas pedal. At a bend in the road that was well-known to the locals to be dangerous, the car swerved right, and he jerked the wheel to the left, but it was too late. The convertible ricocheted across the road, slammed into two young elm trees, spun around, and turned over.

Of the three of them, only Kligman survived the wreckage, though with terrible injuries. Her friend was found crushed under the car. Pollock, though he'd been thrown clear, had died instantly when his head struck a tree. He was forty-four years old. Edith Metzger was only twenty-five.

After Kligman had been taken to the hospital, a photographer showed up and took pictures of the crash scene, which would appear in newspapers in New York and East Hampton within a few days. A week later, his old nemesis *Time* would sneer at Pollock again in death, noting in its "Milestones" column the death of the "bearded shock trooper of modern painting, who spread his canvases on the floor, dribbled paint, sand and broken glass on them, smeared and scratched them, and named them with numbers."[4] Meanwhile Krasner, tracked down at some friends' house in Paris by Greenberg, was flying home for the funeral. It was one day short of a month since she'd left him behind.

She had him buried in the Green River Cemetery in Springs, a place they had visited together often on their walks, and that he had talked of wanting to be buried in. She arranged for a church service, presided over by a local minister who hadn't known him, and who delivered no eulogy. Clement Greenberg had turned down her invitation to do so, on the grounds that if he did, he would have to mention the young woman Pollock had killed, which Krasner refused to allow. Pollock's beloved dogs howled as he was lowered into the grave; his eighty-one-year-old mother stood there stolidly, dry-eyed, on one side of the grave, while Krasner wept on the other.

In his will, Pollock had left everything, including all his paintings, to Krasner. She would outlive him by twenty-eight years, the most famous, most powerful Art Widow—a term coined by Harold Rosenberg—in the world. It was she who would oversee, and manage, the triumphant arc of his posthumous life.

Chapter Ten

Grisly though it sounds, the way Pollock died contributed almost as much to his legend as the Namuth photographs did. Whether he was deliberately trying to kill himself or not, his final car crash only burnished and enhanced his stature as a figure of romance: the doomed artist, pursued by demons, destroyed by William James's bitch-goddess. Death in a speeding convertible on a country road was the ultimate image of recklessness, the very opposite of the organization man's timid, cautious mode of being. What was in fact a tragedy took on the coloring of exultation and triumph.

By the time he died, he had already become a hero to a small group of artists. As Tony Smith told an interviewer, "At the funeral, someone said, 'He was just like the rest of us.' Well, it wasn't true. He had more of the hero about him, and everyone knew it."[1] In the years that followed, he would become a different kind of hero, a presence in the American consciousness.

Of course, from his first emergence into the limelight, there was a sort of patriotic pride that he had finally put American art on the

map. It was the first time that an American artist had been hailed as worthy of talking about in the same breath as the European Modernists. As the critic Peter Schjeldahl has said, "He countered the humiliating authority of European modern art not by rejecting it but by eclipsing it"; he turned abstraction itself into "a homegrown scandal, with nothing sissified about it."[2] But his posthumous fame, and his hold on the public's imagination, go well beyond the paintings themselves. As the English newspaper the *Independent* noted in 2006, "The fascination with the man whom *Time* magazine dubbed Jack the Dripper at the time of his death only seems to get deeper."[3]

There are not only several traditional biographies, but an oral biography compiled by his neighbor, friend, and sometime plumber on Long Island. Tennessee Williams wrote an "Occidental Noh" play about Pollock; other playwrights, too, have dramatized his life and death. He has also inspired or been the subject of tributes in the form of poetry, dance, song, and jazz riffs. Ruth Kligman wrote a memoir of her time with him, and fifty years after his death was still regaling interviewers with the love letters she continued to write him, explaining that "I'm like Cleopatra, and Jackson was like Marc Antony. I think I had met him before. . . . At the moment he died, I believe his soul went into my body."[4]

His fellow painters, his friends in Springs, the man who ran the general store and used to take Pollock up in his small plane, have all spoken about him at length to journalists. Even his Jungian analyst wrote about him. It seems as though everyone who ever knew him has had his or her say. In 2000, a still wider public became aware of his turbulent life with the release of the film *Pollock*, directed by Ed Harris, who also played the title role. (One cannot imagine a film called simply *De Kooning* or *Rothko*.)

His painting *Convergence* has been made into a jigsaw puzzle that its manufacturers boast is the most difficult in the world. A CD called *Jackson Pollock: Jazz* features selections from his record

collection. Tongue-in-cheek artworks, including *Guernica as Painted by Jackson Pollock* and *Jackson Pollock's Mother*, a photograph of a woman in a splattered apron, are for sale in commercial poster and postcard shops. A website has been created (www.jacksonpollock .org) where people can make their own pseudo–drip paintings, using a mouse. Fashion designers have cited him as the inspiration for clothing that features paint-splattered denim or smudges of "practically every color in the Benjamin Moore catalog."[5] There is even a cocktail called Jack the Dripper.

Pollock's and Krasner's property in Springs has been designated a National Historic Landmark, in recognition of "its significance as one of the nation's most important cultural monuments." After the Stony Brook Foundation took over the property in 1987, the floor that had been installed in 1953 was removed, revealing the original paint-stained floorboards, bearing copious traces of Pollock's work on such paintings as *Autumn Rhythm*. Pollock's brushes, the thickly encrusted paint cans in which he stored and cleaned them, his jars of pigment, and even his paint-splattered work shoes are on display—talismanic objects—along with photographs of him at work. In the house, many of his old jazz LPs are neatly lined up on a shelf. In short, it has become a shrine, and thousands of pilgrims have flocked there since it opened its doors to the public.

It is telling that the *Independent*'s journalist did not say "the fascination with the work of the man," but simply "the fascination with the man." Even when we look at the paintings, the man is there too. Namuth's photographs of him in his studio are not only the best record we have of a painter's process; they capture as perhaps nothing else ever has the mysterious power, the exultation, of the artist in the act of creation. One feels something of what Coleridge describes in the stanza from "Kubla Khan" that serves as the first epigraph for this book, and that remains the supreme expression in words of the romantic conception of the artist. Pollock,

as he dances around the canvas in his blue jeans and T-shirt, is the American version of that figure.

And then there are the other photographs of him, sitting on the running board of his Model A Ford, or lounging up against a wall, arms crossed in front of his chest, a cigarette between his fingers or dangling from his mouth. These images, too, have become iconic: once seen, they too become part of the experience of looking at Pollock's paintings. He is imprinted on our retinas in a way that no other visual artist—except maybe his polar opposite, the ultra-cool, affectless Andy Warhol—ever has been.

Like van Gogh, he has been romanticized as a wild-man painter, a tormented genius who applied paint with a passionate directness and immediacy expressive of intense feeling—also as a man destroyed by the very sensitivity that enabled him to create great art: the "clam without a shell," for whom the world was too cruel and abrasive a place for him ever to be at home in it. The great contrast between them is the contrast between a supremely articulate artist and one for whom words were not a possible outlet. It is his physical presence, and that of his paintings, that is indelible. Whereas photographs freeze them into stasis, rendering them flat and dead, the drip paintings themselves seem to vibrate, emitting what feels like an electrical charge. As the *New York Times* critic Roberta Smith once wrote of them in that newspaper, they "virtually explode off the . . . wall."[6]

* * *

On a more prosaic level, Pollock is also famous to millions of people impervious to the magnetism of either his work or his persona, for the simple reason that prices for his paintings have continued to make news for almost forty years. If his January 1949 exhibition at Parsons was his only really profitable show during his

lifetime—Tony Smith remembered that Pollock's total income for a year in the early fifties was somewhere in the region of $2,600, not a princely sum even then—the situation changed radically after his death.

Beginning in the early sixties, Krasner came to be regarded in the art world as an extremely canny "dealer": rather than flooding the market with Pollocks, she hung on to many of them for years and sold them one or two at a time, ensuring that demand would always exceed supply and thereby driving up prices. (Her handling of the Pollock estate also affected the market for other Abstract Expressionists' work; Harold Rosenberg credited her with "almost single-handedly forc[ing] up prices for contemporary American abstract art.")[7] Blunt, cantankerous, domineering, Krasner was accused of reveling in her power. But as she repeatedly said, it was not shrewdness or a desire to manipulate the market that led her to be so grudging about releasing the Pollocks in her possession. It was, simply, that she hated to get rid of them: they were all she had left of him.

Though she had a fierce conviction that, when prices for art began soaring, the price of a Pollock ought to be higher than that for anything else, Krasner was still passionately committed to the idea of art as a sort of secular religion, not another marketplace activity. Perhaps partly for that reason, according to Pollock's nephew the art dealer Jason McCoy, she sold the works in her possession primarily to museums and other public collections, where they could be seen by others besides the very rich.[8]

In 1973, when the National Gallery of Australia bought Pollock's *Blue Poles* for $2 million, headlines around the world reported not only that it was the highest price ever paid for a contemporary painting, but also that Australian taxpayers were up in arms. By the time of Krasner's death in 1984, the drip paintings were going for many times that amount. And in 2006, a Pollock once more became

the most expensive contemporary artwork in existence when the Hollywood mogul David Geffen, in a private sale, reportedly sold *No. 5, 1948* to a Mexican banker for $140 million. Again, newspapers all over the globe announced the price with much fanfare.

In her will, Krasner, who had rededicated herself to her own painting after Pollock's death and increasingly been recognized as a serious artist in her own right, left the bulk of her fortune to a charitable foundation she had established, whose primary purpose was to provide grants to individual visual artists based on both merit and need. She may have remembered how, in the bad winter of 1948, Pollock had received a grant from the Demarest Trust Fund that enabled him to go on painting. (She may have recalled, too, that his grant application to the Guggenheim Foundation had been rejected.) As of this writing, the Pollock-Krasner Foundation has given away more than $50 million.

*　*　*

Just as the prices of Pollocks make headlines in the mainstream media, there has also been extensive coverage of the controversies surrounding the discovery, in unlikely places, of what were claimed to be previously unknown Pollocks. In 1992, Teri Horton, a former long-haul trucker living in a trailer park in California, paid five dollars for a painting she found in a thrift shop and intended to use as a dartboard. She then put it in a yard sale, where it was spotted by a passing art teacher who told her that it looked like a Jackson Pollock. Upon learning the prices that Pollocks were fetching, Horton was no more convinced than before that the painting she owned was an object of beauty—she continued to find it ugly, and to call it so. But she did become obsessed with the idea of the changes she could effect in her own and her children's hard lives by selling her thrift-shop find for a similar fortune. In the course of her long battle

to get the painting authenticated, she became a sort of mini-celebrity herself, appearing on David Letterman's show and on *60 Minutes* and as the subject of a documentary whose title was taken from her initial response to the news that her five-dollar painting might be a Pollock: *Who the #$&% Is Jackson Pollock?*

A purported forensics expert with a specialty in art claimed to have found a Pollock fingerprint on Horton's painting, though his integrity was later called into doubt, and the validity of his methods questioned by a fingerprint expert of long standing. There were even allegations that the fingerprint had been forged—transferred onto the painting via an inked rubber stamp made from a cast of a Pollock print on a paint can. And when the same forensic expert announced he'd also found a Pollock fingerprint on another disputed Pollock, it was hard to take him seriously. In fact, even before the fingerprint controversy, experts like the late Thomas Hoving, a former director of the Metropolitan Museum, had scoffed at Horton's claims for her painting; it was, said Hoving, "too neat and too sweet" to be a real Pollock, and besides, it was painted with acrylics, which Pollock never used.[9]

Ten years later, Alex Matter, a filmmaker whose parents had been close friends of the Pollocks from the thirties on, found a cache of paintings that his late father had wrapped in a bundle and designated as Pollock's. While some of the paintings had disintegrated past the point of redemption, thirty-four had survived reasonably intact. Two distinguished Pollock scholars, after careful examination, vouched for the works' authenticity—apart from their resemblance to certain undoubted Pollocks, they showed every sign of having been created through the working methods Pollock typically used. Then various other experts argued that the paintings could not possibly be Pollocks: they were too cramped, too frenzied, too over-earnest.

When forensic tests, including tests on the paints used in the

works, were carried out, some of the paints were found not to have been produced, or at least not made commercially available, until years after Pollock's death. Much speculation then arose about the source of Alex Matter's paintings; there was some suggestion that they might have been made by his mother's art students.

Neither dispute has yet been conclusively laid to rest, and it is certain that there will be other controversial Pollock discoveries in the future. Whether they will be resolved by scientific analysis or by the aesthetic judgment of those whose long-standing involvement with Pollock's work make their instinctive responses particularly trustworthy is not yet clear.

In both cases, the problem of establishing authenticity and the differing conclusions arrived at by respected scholars and connoisseurs, not to mention the scientists involved, highlighted the particular difficulty of authenticating the kind of work Pollock produced. And the controversies inevitably reopened the uncomfortable question, in the public mind at least, of how authentic Pollock's work was in and of itself—whether it might not be, as has been said of abstract art in general, "a product of the untalented, sold by the unprincipled to the utterly bewildered." (It seems worth noting that this remark has been attributed variously to Albert Camus and to the American humorist Al Capp, a very odd juxtaposition.) Pollock himself had doubts about the drip paintings: famously, he once summoned Krasner into his studio, pointed at his latest canvas, and asked her, "Is that a painting?" Not, as she remarked, "Is that a good painting?" but simply "Is that a painting?" It was a question asked by many other people at the time, and one that continues to be asked by a large percentage of the population today.

Peter Schjeldahl, however, offers an interesting counterweight to the argument that the difficulty of authenticating a Pollock suggests something dubious about his whole enterprise: "Pollock at his peak burned his past conditioning and present turmoil, his very

identity and character as a man, and he burned them clean. There's nobody to recognize. That's why it can be hard at first sight to tell a true Pollock from a fake. He prepared us to believe that absolutely anything was possible for him. What determines authenticity for me is a hardly scientific, no doubt fallible intuition of a raging need that found respite only in art."[10]

Chapter Eleven

However vibrant a presence Pollock has become in American culture at large, one would expect him to have left his most indelible mark on the painters who came after him. Yet while the Namuth films and photographs directly inspired a generation of performance and body artists, taking art in a whole new direction, tracing Pollock's influence on painting itself is a much less straightforward matter.

The one aspect of contemporary painting where his legacy is apparent even in the work of artists whose style bears no resemblance to his own has to do with size. Before Pollock, it was almost unheard of for contemporary painters to work on such huge canvases; after him, it seemed like normal practice. Thus, as the painter and Royal Academician Tess Jaray has said, "When we first saw his work in the fifties, it was really a shock to see such huge paintings, a revelation; it bowled us over. The excitement we felt was, in part, a sense of amazement, not only at his technique, but at the sheer bravado of the size of his canvases. When we saw them again thirty

or forty years later, they no longer had the same power to shock precisely because we had all grown accustomed to seeing paintings of that size. Indeed, many of us had painted them ourselves."[1] Pollock did more than anyone to make Greenberg's prophecy about the death of easel painting come true.

In other ways, his influence on painting is difficult to pin down. Though he had many imitators—art students were churning out drip paintings by the thousands in the decade after his death—he had few direct heirs.

Other painters made use of the techniques he had pioneered, adapting them for their own ends, but nobody found a way to go a step farther down the path he had forged. He had taken painting as far as it could go in that direction, much as, in *Finnegans Wake*, James Joyce had both discovered and virtually exhausted a radical new literary technique. While Greenberg declared that it was Clyfford Still who "shows abstract painting a way beyond Late Cubism that can be taken, as Pollock's cannot, by other artists," among the Abstract Expressionists it was de Kooning who most attracted followers, directly influencing many younger painters.[2] The artist Joseph Kosuth offered this ironic explanation: "When you faked a Pollock, it looked like a fake Pollock; when you faked a de Kooning, it looked like a great painting."[3]

Those who did try "faking" a Pollock convincingly were surprised at just how difficult it was. Mike Bidlo, a postmodernist artist who specializes in duplicating from scratch the styles and specific works of bygone modernist greats, attested that, while he had thought it would be easy to create a Pollock, it took him months of dogged practice to come up with anything credible. Ed Harris, in preparation for playing the title role in his film about Pollock's life, thought it essential to learn to paint in Pollock's manner and, like Bidlo, discovered how difficult it was; after months of practice, he still wasn't satisfied that he'd managed it.[4]

The painter most clearly indebted to Pollock was Helen Franken-thaler, a second-generation Abstract Expressionist who also worked on the floor and used a pouring technique, but in a very different fashion and to a very different end from Pollock's. By diluting paint with turpentine and pouring it directly onto unprimed cotton duck, so that the color would bleed into the canvas rather than staying on the surface, she created works that were much more serene, and also much more classically "beautiful," than Pollock's, with gorgeous pastel colors and halos around the areas where the paint had been applied.

To the Color Field painters of the late fifties and sixties, Kenneth Noland and Morris Louis chief among them, Frankenthaler's staining technique and her method of working were the inspiration that led them to break through into their own distinctive styles; hence they could be said to have been influenced, indirectly, by Pollock. (Louis called Frankenthaler the bridge "between Pollock and what was possible.")[5] But Louis's delicate, translucent veils of color, created by pouring heavily diluted paint onto unprimed canvas, are, like Frankenthaler's paintings, very different in spirit from Pollock's work, lacking not only its gestural qualities but, concomitantly, its visceral power and rawness.

And as the sixties wore on, Pollock became not so much an influence on painters as the predecessor to rebel against; they defined themselves in opposition to him, rather than following in his footsteps. The rigidity and conceptual emphasis of both Pop Art and the Minimalism that came to prominence during that time are often seen—perhaps not inaccurately—as an almost involuntary reaction to the frustration of being unable to ape the legendary spontaneity of Pollock in the studio. Robert Rauschenberg once told the critic Kenneth Baker that "he wasn't against Abstract Expressionism, it was just that it took up a lot of space in the New York art world and because there was no place for him in it, he had to create his own."

Similarly, Sol LeWitt's minimalist wall drawings, first created in New York in the late 1960s, are characterized by Baker as "a revisionary response to Pollock's way of taking over a wall and a room."[6] And though Frank Stella paid homage to Pollock, and was inspired by his use of aluminum paint to make his own aluminum paintings, his highly controlled, deliberately anti-expressionist work of the sixties could not have appeared more dissimilar to Pollock's.

Pop Art, which trafficked in cool impersonal ironies rather than the passionate high seriousness of Abstract Expressionism, and which came to be the dominant mode of painting as the sixties wore on, was in part a conscious rebellion against the earnestness of its predecessors. The Pop Artists, several of whom had worked in advertising, turned away from abstraction altogether, co-opting images of "low" culture, like comic books, and thereby blurring or refusing the distinction between highbrow and lowbrow. Deliberately reflecting the way our experience of the world had come to be filtered through the mass media, they were not setting themselves up in opposition to the culture of mainstream America, but were embracing it instead. Art had become fun, of however serious a kind. It was a very different American spirit that was being reflected, not the purist, Puritan, fanatically moral spirit of the Abstract Expressionists but the new consumerism and hedonism of the postwar age.

Nor was the artist any longer an outsider. As early as 1966, Harold Rosenberg wrote, in what may have been an exaggeration then but would soon prove to be a simple statement of fact: "Instead of resigning himself to a life of bohemian disorder and frustration, he [the artist—Rosenberg's assumption being that every artist must be a he] may now look forward to a career in which the possibilities are limitless. In short, painting is no longer a haven for self-defeating contemplatives, but a glamorous arena in which performers of talent may rival the celebrity of senators or TV stars." Or, as one younger critic blithely put it, "Suffering is no longer fashionable."[7]

In the eighties—when, ironically enough, gestural painting once more came to the forefront, and the painters known as Neo-Expressionists began creating large canvases referring back to the Abstract Expressionists' work—art, fashion, and money formed ever more potent alliances, and the art world became commercialized in a way that Pollock could never have imagined. Art colleges began offering their students courses in how to manage their careers through a judicious use of public relations tactics and the deliberate creation of an arresting public persona. It became a commonplace that salesmanship was half of the artist's job.

The first celebrity of twentieth-century American art, Pollock was the premier example of the artist as name brand, as marketable commodity. Yet he remained the inspiration for various forms of art—body art, performance art, conceptual art—that, concerned as they were with process alone, engendered no saleable product, and were therefore an implicit or explicit protest against the increasing "commodification" of art. Ironically, then, Pollock can be cited as a seminal influence on both the trend against the commercialization of art in the last decades of the century and the forces pulling so powerfully in the other direction.

* * *

Perhaps inevitably, there has also been a backlash against the glorification of Pollock, particularly among the current generation of academic art historians, who disdain what the critic Amelia Jones calls the "largely unquestioned, heroic 'Pollock'" still accepted by the "less specialized public."[8]

First, there is the matter of the political uses to which his work was put—the question of whether it was promoted abroad as part of a deliberate campaign to advance American interests there. Starting in the seventies, the politics of all the Abstract Expressionists

became an object of suspicion, it having been discovered that the CIA, in its attempt to promote the reputation of American artists and thereby increase the prestige of the country at large, had financed international exhibitions of their work during the Cold War. The critic Eva Cockcroft summed it up bluntly in an influential 1974 article in *Artforum* titled "Abstract Expressionism, Weapon of the Cold War."[9]

Having been regarded as dangerously "Communistic" in their own day, the Abstract Expressionists began to be seen as witting or unwitting tools of American capitalism and imperialism. It was argued that their fame was based not on the intrinsic merit of their work, but on the efforts of the American government to establish American dominance in the cultural sphere as well as the geopolitical one. The French-born art historian Serge Guilbaut, in his ongoing critique of the political purposes Abstract Expressionism had been made to serve, concluded that Pollock's paintings in particular were simply what "the culture wants represented now, wants to make use of, because capitalism at a certain stage of its development *needs* a more convincing account of the bodily, the sensual, the 'free' in order to extend—perhaps to perfect—its colonization of everyday life."[10]

Even more problematic for the post-sixties generation of both critics and artists was Pollock's blatantly macho persona; his paintings, once admired for their "ravaging, aggressive virility,"[11] were reinterpreted, damningly, as "the acting out of the phallocentric male fantasy on the symbolically supine canvas."[12] And while body artists continued to be influenced by the version of Pollock presented to the world by Namuth, beginning in the seventies even they were more concerned to question, deconstruct, and subvert the myth of Pollock (American art's supreme white macho male, an icon of society's received notions about masculinity as an exclusively heterosexual province) than to celebrate it. Or, as Amelia Jones puts it:

"In particular, artists who have a stake in interrogating the aggressive *masculinism* [*sic*] of Pollock (again, with the whiteness, heterosexuality, and class implications attached to this privileged subject position in modernism) have produced powerful body art projects that reiterate the histrionic model of Pollock painting through nonnormative artistic bodies that unhinge the values associated with the author function Pollock."[13]

If his machismo became a provocation to various gay and feminist artists who sought to lodge a protest against it with their own work, it also led to a view of him not as a tormented but great innovator, the man who put American art on the map, but simply an old-fashioned brute: Stanley Kowalski with a paintbrush.

Says Bill Arning, director of the Contemporary Arts Museum Houston, "Younger artists mock him as a caricature of masculinity, almost on the level of MTV."[14] Nor do they go to his paintings for inspiration; the interest in his work continues to be an interest in the "performance" by which it was created, rather than the art itself. Thus, when in 2007 the artist Aaron Young imprinted a vast 9,216-square-foot canvas with vaguely Pollock-like skeins and whorls of paint by having motorcycles driven back and forth over its surface, the focus of his tongue-in-cheek homage to Pollock was very much the process, not the product. If the video that captured that process—the motorbikes' journey across the expanse of canvas—was far more exciting and impressive than Young's product—the painting itself—it has also, tellingly, been seen by many more people than the painting has.

What the current generation of artists is finally most deeply skeptical about, however, is the view of Pollock as a heroic figure, that being a construct which simply does not exist in their scheme of things. Back in the fifties, Greenberg wrote of Pollock's "inability to be less than honest," a judgment on the work rather than the man, but one that, at the time, seemed to many people true of Pollock

personally as well.[15] In the decade after his death those who spoke and wrote about him tended to present him as possessed of great courage and integrity; the enormous risks he had taken in his work, his refusal to compromise either by making work deliberately designed to please or by going on making the sort of paintings that had brought him fame, seemed proof of that. But as David Lloyd Brown, an associate dean at the School of the Museum of Fine Arts, Boston, points out, "Contemporary academics and art critics are no longer willing to be reverential about Pollock, or to accept the early texts about him in an un-critical spirit."[16]

Maybe that's because the whole idea of the solitary creator is itself seen as deeply suspect, a romantic myth crying out for debunking. A more social, political construction of the nature of "art-making" has become firmly entrenched, and the very notions of beauty and genius and artistic struggle are seen as, at best, the residue of an outmoded aestheticism; at worst, as yet another strategy through which the oppressive, elitist, patriarchal hegemony tries to cling to its power. In this view of things, so far from being the figure conjured up by Schjeldahl, or the hero of Tony Smith's formulation, Pollock is simply the rapist of canvases, or the dominant competitor in the art market of the 1950s.

Meanwhile, younger artists, like their professors—art having become much more the province of the academies these days—are equally skeptical of the idea that art is a calling, in the religious sense, and that one of its functions is to transport us into the realm of the holy. To quote Arning again: "Younger artists can no longer buy into the idea of greatness. They don't believe in heroes, they don't believe in art as a religion, and they certainly can't accept the kind of psychological Jungian constructs that were part of the interpretative toolkit of the time. They're more interested in deconstructing the mechanisms of celebrity around Pollock."[17]

"After seventy years of contemporary art, he has become a sort of rock-star figure to younger artists, and that cuts both ways," says David Lloyd Brown. "They tend to feel that he has received more attention than he deserved, just because of his persona. From a pedagogical perspective, they're taught to be cynical about his position in art history. At the same time, they understand the irresistible pull any media star commands."[18] Arning, too, refers to the attraction of Pollock's "rock-star aura" and points out that even the Metropolitan Museum of Art, when it showed his works on paper, also showed a photograph of him shirtless, "like a rock star."[19]

Whether one regards the prevailing scorn for the notion of greatness as healthy skepticism or simply shallow knowingness masquerading as wisdom, the focus on Pollock's stardom and his bare chest seems as good a "signifier" as any of the changes that have taken place in American culture, and the society at large, since his death. One could almost map the seismic shifts in the cultural temper of America over the last fifty years by tracking the changes in the way Pollock has been regarded during that time.

Yet the paintings remain, and there will always be people who keep returning to them. At their most powerful they continue both to reflect the spirit of the age in which they were created and to constitute a highly individual response to that age.

In a world radically transformed by war, a world in which ideas about the nature of the human had been revolutionized by developments in psychoanalysis on the one hand and unprecedented revelations of evil on the other, representational forms no longer seemed adequate for expressing what the artist needed to convey. At the same time that Pollock was drawing on ancient mythological archetypes and contemplating the possibility of world destruction, he was also fulfilling and extending the injunctions of other radical artists: from Michelangelo's famous notion of releasing the form that already

existed within the stone to Picasso's bravura statement, "Others have seen what is and asked why. I have seen what could be and asked why not."[20]

In Pollock's hands, the material he used—the "stuff" of paint—was enabled to release its potent energy in a whole new way, so that it took on almost the force of a scientific discovery, like the splitting of the atom. That is one way of looking at Pollock's achievement. Another is to argue that his paintings mirrored the explosive energy that had been released into the world when the atom was split. Or one can simply say, as Tennessee Williams did, that "he painted ecstasy as it could not be written."[21]

Acknowledgments

I am indebted to the work of many Pollock scholars, critics, and biographers. While they are too numerous for me to mention all of them here, I want to record my especial debt to the writings of Ellen Landau, Kirk Varnedoe, Elizabeth Frank, Deborah Solomon, and Pepe Karmel, as well of course as Clement Greenberg. For details of Pollock's life, I have benefited from the exhaustive research of Steven Naifeh and Gregory White Smith.

The staff at the London Library, the British Library, and the library of the University of East Anglia were enormously helpful and knowledgeable, as well as unfailingly patient, as I searched for material on the political and social climate of the forties and fifties, in addition to books that dealt directly with Pollock and his art.

I am grateful to the many people who spoke to me or corresponded with me about Pollock, in particular Bill Arning, David Lloyd Brown, Claude Cernuschi, Geoff Edgers, Lynn Freed, Helen Harrison, Tess Jaray, Robert Kerwin, Jason McCoy, Rozsika Parker, and Geoff Rigden. Special thanks to Kenneth Baker for

shedding light, as always, and to Arthur C. Danto for his generous comments.

My thanks also to the staff of Yale University Press, particularly Jack Borrebach, for his scrupulous care in going over the final manuscript, John Palmer, for dealing with various recalcitrant photographers and many different copyright holders, and Sarah Miller, for her editorial suggestions at a crucial stage of the writing process.

Finally, I am deeply grateful to Lee Krasner, whose reminiscences and conversation more than thirty years ago first gave me a vivid sense of Jackson Pollock and how she herself saw his work.

Notes

Introduction

1. Roundtable on contemporary art, *Life*, October 11, 1948.
2. "Jackson Pollock," *Life*, August 8, 1949.
3. Luce's editorial is quoted in Alan Brinkley, *The Publisher: Henry Luce and His American Century* (New York: Knopf, 2010), p. 269.
4. Quoted in Robert Lebel, *Marcel Duchamp* (New York: Paragraphic Books, 1967), p. 78.
5. Quoted in Brinkley, *The Publisher*, p. 269.
6. Quoted in Naifeh and Smith, *Jackson Pollock: An American Saga*, p. 595.

Chapter One

1. Quoted in Sandler, *Abstract Expressionism and the American Experience*, p. 7.
2. Quoted in David Pryce-Jones, "Andre Malraux: Politicizing Literature, Fictionalizing Politics," *New Criterion*, March 2005, pp. 61, 63.
3. Quoted in Susan Platt, "Seattle: Mary Henry," *Art Papers*, 2002.
4. Chipp, *Theories of Modern Art*, p. 360.
5. Ibid., p. 412.
6. Analyst quoted in Friedman, *Jackson Pollock: Energy Made Visible*, p. 42.
7. Quoted in Craven, *Abstract Expressionism as Cultural Critique*, p. 42.

8. Newman quoted in Chipp, *Theories of Modern Art*, p. 553; Rothko described in Breslin, *Mark Rothko*, p. 58, and quoted at p. 166.

9. Hughes, *Shock of the New*, p. 313.

10. Ibid., p. 131.

11. Wordsworth, "Lines written a few miles above Tintern Abbey, on revisiting the banks of the Wye during a tour," lines 96–100.

12. Emerson quoted in Lyndall Gordon, *Lives Like Loaded Guns* (New York: Viking, 2010), p. 53; Whitman, "Song of Myself," Section 51.

Chapter Two

1. Hughes, *Shock of the New*, p. 314.

2. Quoted in Solomon, *Jackson Pollock*, p. 39.

3. Quoted in Charles Starmer-Smith, "Ranching with Cowboys in Wild West Wyoming," *Daily Telegraph*, March 6, 2009.

4. Harrison, *Such Desperate Joy*, p. 246.

5. Diski, *Don't*, p. 118.

6. Frank, *Pollock*, p. 39.

7. Friedman, *Jackson Pollock: Energy Made Visible*, p. 43.

8. Harrison, *Such Desperate Joy*, pp. 88, 89.

9. Quoted in Wood et al., *Modernism in Dispute*, p. 8.

10. Harrison, *Such Desperate Joy*, p. 88.

11. Solomon, *Jackson Pollock*, p. 108; *ARTnews*, December 1961, p. 58.

12. Quoted in Toibin, *Love in a Dark Time*, p. 202.

Chapter Three

1. Quoted in Gill, *Art Lover*, p. 278.

2. Anonymous art dealer quoted in Gill, *Art Lover*, p. 279.

3. Friedman, *Jackson Pollock: Energy Made Visible*, p. 53.

4. Clement Greenberg, review in *The Nation*, November 27, 1943.

5. Varnedoe, interviewed by Jeffrey Brown on *PBS NewsHour*, January 11, 1999.

6. Varnedoe, *Jackson Pollock*, p. 40.

Chapter Four

1. Clement Greenberg, review in *The Nation*, April 7, 1945.

2. Greenberg, "Modernist Painting," in *Collected Essays and Criticism*, Volume 4, p. 87.

3. Quoted in Fineberg, *Art Since 1940*, p. 91.

4. Landau, *Jackson Pollock*, p. 156.

5. Greenberg, review in the *Nation*, April 13, 1946.

6. Quoted in Karmel, *Jackson Pollock: Interviews, Articles, and Reviews*, p. 19.

7. Solomon, *Jackson Pollock*, p. 189.

Chapter Five

1. Karmel, *Jackson Pollock: Interviews, Articles, and Reviews*, p. 13.

2. Schjeldahl, "American Abstract."

3. Greenberg, *Art and Culture*, p. 218.

4. Greenberg, review in the *Nation*, April 13, 1946.

5. Saltz, "The Tempest."

6. Pollock quoted in Frank, *Pollock*, p. 110; Kandinsky, *Concerning the Spiritual in Art*, p. 1.

7. Kenneth Baker, e-mail to the author, September 2010.

8. Chipp, *Theories of Modern Art*, p. 546.

9. Friedman, *Jackson Pollock: Energy Made Visible*, p. 21.

10. Karmel, *Jackson Pollock: Interviews, Articles and Reviews*, p. 16.

11. Pater, *The Renaissance*, pp. 95, 98; Steiner, *Real Presences*, p. 196.

12. O'Connor, *Jackson Pollock*, p. 40.

13. Quoted in Karmel, *Jackson Pollock: Interviews, Articles, and Reviews*, pp. 138, 22 (interview with William Wright).

14. O'Meally, *Jazz Cadence of American Culture*, p. 179.

15. Ratcliff, *Fate of a Gesture*, p. 3; Ratcliff, "Jackson Pollock and American Painting's Whitmanesque Episode."

16. Hughes, *Shock of the New*, pp. 311 (quoting Whitman), 314.

17. Charles Olson, *Call Me Ishmael* (New York: Grove Press, 1947), p. 1.

Chapter Six

1. Harrison, *Such Desperate Joy*, p. 93.

2. De Kooning quoted in Solomon, *Jackson Pollock*, p. 178.

3. Quoted in Sandler, *Abstract Expressionism and the American Experience*, p. 213.

4. Guilbaut, *How New York Stole the Idea of Modern Art*, p. 193.

5. *New York Times*, November 27, 1949.

6. *New York Sun*, December 23, 1949.

7. *Time*, December 26, 1949.

8. Varnedoe with Karmel, *Jackson Pollock: Interviews, Articles and Reviews*, p. 21 (interview with William Wright).

9. Peter Plagens, "Whose Art Is It, Anyway?" *Nation*, October 12, 2006.

10. Quoted in Craven, *Abstract Expressionism as Cultural Critique*, pp. 96–97.

11. Jachec, *Philosophy and Politics of Abstract Expressionism*, p. 168

12. Solomon, *Jackson Pollock*, p. 207.

13. Varnedoe, *Jackson Pollock*, pp. 89–90.

Chapter Seven

1. Interview with Jeffrey Brown, *PBS NewsHour*, January 11, 1999.

2. Varnedoe, *Jackson Pollock*, p. 90.

3. Rosenberg, *ARTnews*, December 1952.

4. Kaprow, "The Legacy of Jackson Pollock."

5. Naifeh and Smith, *Jackson Pollock: An American Saga*, p. 63.

6. Quoted, in translation, in O'Connor, *Jackson Pollock*, p. 55.

7. Naifeh and Smith, *Jackson Pollock: An American Saga*, p. 628.

8. Brooks quoted in Harrison, *Such Desperate Joy*, p. 239.

9. James, *Letters of William James*, Vol. 2, p. 260; James, *The Will to Believe and Other Essays*, p. 47.

10. Dickinson, "I was the slightest in the House," line 9.

11. Quoted in Sandler, *A Sweeper-Up After Artists*, p. 54.

12. Ibid., p. 95.

13. Friedman, *Jackson Pollock*, p. 223.

Chapter Eight

1. Greenberg, review in the *Partisan Review*, January–February 1952.

2. O'Hara, *Jackson Pollock*, p. 26.

3. Potter, *To a Violent Grave*, p. 167.

4. *New York Times* review quoted in Friedman, *Jackson Pollock: Energy Made Visible*, p. 206; *New York Herald-Tribune*, February 7, 1954.

5. Greenberg, *Affirmations and Refusals*, p. 226.

6. Quoted in Naifeh and Smith, *Jackson Pollock: An American Saga*, pp. 742–43.

7. Solomon, *Jackson Pollock*, p. 13.

8. Wakefield, *New York in the Fifties*, p. 128.

9. Sigmund Freud, "Taboo and Emotional Ambivalence," *Standard Edition of the Complete Works*, Vol. 13, p. 49.

10. Letter from Dylan Thomas to his parents, in *Selected Letters of Dylan Thomas*, edited by Constantine Fitzgibbon (London: JM Dent & Sons, 1966), p. 348.

Chapter Nine

1. Review in *Time*, December 19, 1955.
2. Naifeh and Smith, *Jackson Pollock: An American Saga*, p. 761.
3. Pollock quoted ibid., p. 628; Tsvetaeva in Claudia Roth Pierpont, *Passionate Minds: Women Rewriting the World* (New York: Knopf, 2000), p. 188
4. "Milestones," *Time*, August 20, 1956.

Chapter Ten

1. Interview with Tony Smith, *Art in America*, May–June 1967.
2. Schjeldahl, "American Abstract."
3. Usborne, "Portrait of the Artist."
4. Harrison, *Such Desperate Joy*, pp. 291, 287.
5. Limnander, "Jack the Dripper."
6. Smith, "Rivalry Played out on Canvas and Page."
7. Quoted in Levin, *Lee Krasner*, p. 398.
8. Jason McCoy, in conversation with the author, June 2010.
9. Hoving, "The Fate of the $5 Pollock."
10. Schjeldahl, "American Abstract."

Chapter Eleven

1. E-mail from Tess Jaray to the author, February 2010.
2. Greenberg, *Art and Culture*, p. 224
3. Quoted in Sandler, *A Sweeper-Up After Artists*, p. 190.
4. Both Bidlo's and Harris's observations recounted by the critic Kenneth Baker in an e-mail to the author, September 2010.
5. Quoted in Rose, *American Painting*, p. 100.
6. E-mail from Kenneth Baker to the author, September 2010.
7. Both quoted in Sandler, *Abstract Expressionism and the American Experience*, p. 214.
8. Jones, *Body Art/Performing the Subject*, p. 92.
9. Reprinted in Frascina, *Pollock and After*.
10. Guilbaut, *Reconstructing Modernism*, p. 180.
11. Quoted in Michael Leja, "Reframing Abstract Expressionism," in Frascina, *Pollock and After*, p. 353.
12. Molyneux, "Expression of an Age."
13. Jones, *Body Art/Performing the Subject*, p. 93.

14. William Arning, in conversation with the author, August 2010.

15. Greenberg, "Jackson Pollock: Inspiration, Vision, Intuitive Decision," *Vogue*, April 1, 1967.

16. David Lloyd Brown, in conversation with the author, October 2010.

17. William Arning, in conversation with the author, August 2010.

18. David Lloyd Brown, in conversation with the author, October 2010.

19. William Arning, in conversation with the author, August 2010.

20. Picasso's widely quoted statement was invoked, in conversation with the author in April 2010, by Tess Jaray, who also provided much of the stimulus for the ideas expressed in this and the following paragraph.

21. Williams, *Memoirs*, p. 250.

Bibliography

Adams, Henry. "Decoding Jackson Pollock." *Smithsonian*, November 2009.

———. *Tom and Jack: The Intertwined Lives of Thomas Hart Benton and Jackson Pollock*. New York: Bloomsbury, 2009.

Auping, Michael, organizer, in association with the Albright-Knox Gallery. *Abstract Expressionism: The Critical Developments*. New York: Harry N. Abrams, Inc., 1987.

Baring, Louise. "Jackson Pollock for $5—True or False?" *Daily Telegraph* (U.K.), November 6, 2006.

Barrett, William. *The Truants: Adventures Among the Intellectuals*. Garden City, NY: Anchor Press, 1982.

Breslin, James E. B. *Mark Rothko: A Biography*. Chicago: University of Chicago Press, 1993.

Brinnin, John Malcolm. *Dylan Thomas in America*. London: JM Dent and Sons Ltd., 1956.

Buchanan, Mark. "Jackson Pollock's 'Fractals' Painted in a New Light." *New Scientist*, November 10, 2007.

Chipp, Herschel B., ed. *Theories of Modern Art: A Source Book by Artists and Critics.* Berkeley and Los Angeles: University of California Press, 1968.

Cook, Greg. "A Case of Identity." *Boston Phoenix*, September 4, 2007.

Craven, David. *Abstract Expressionism as Cultural Critique: Dissent During the McCarthy Period.* New York: Cambridge University Press, 1999.

Danto, Arthur Coleman. "Art After the End of Art." *Artforum*, April 1993.

Diski, Jenny. *Don't.* London: Granta Books, 1998.

Edgers, Geoff. "Harvard Study Casts More Doubt on Disputed Pollock Paintings." *Boston Globe*, January 30, 2007.

Emmerling, Leonhard. *Jackson Pollock.* Los Angeles: Taschen, 2007.

Fineberg, Jonathan. *Art Since 1940: Strategies of Being* (Second Edition). London: Laurence King Publishing, 2000.

Fleming, Colin. "Doppelgangin'." *Salmagundi*, Fall 2009.

Frank, Elizabeth. *Pollock.* New York: Abbeville Press, 1983.

Franz Kline Remembered. Television broadcast. Los Angeles: Cort Productions, 1983.

Frascina, Francis, ed. *Pollock and After: The Critical Debate* (Second Edition). New York: Routledge, 2000.

Freedman, Stanley P. "Loopholes in Blue Poles." *New York*, October 29, 1973.

Friedman, B. H. *Jackson Pollock: Energy Made Visible.* London: Weidenfeld and Nicolson, 1973.

Gill, Anton. *Art Lover: A Biography of Peggy Guggenheim.* New York: HarperCollins, 2002.

Greenberg, Clement. *Art and Culture.* Boston: Beacon Press, 1961.

———. *The Collected Essays and Criticism.* Volumes 1–4. John O'Brian, ed. Chicago: University of Chicago Press, 1986, 1993.

Guggenheim, Peggy. *Out of This Century: Confessions of an Art Addict.* London: Andre Deutsch, 1980.

Guilbaut, Serge. *How New York Stole the Idea of Modern Art.* Chicago: University of Chicago Press, 1983.

————, ed. *Reconstructing Modernism: Art in New York, Paris, and Montreal, 1949–1954.* Cambridge, MA: MIT Press, 1990.

Harrison, Helen A., ed. *Such Desperate Joy: Imagining Jackson Pollock.* New York: Thunder's Mouth Press, 2000.

Hobbs, Robert Carleton, and Gail Levin. *Abstract Expressionism: The Formative Years.* Ithaca, NY, and London: Cornell University Press, 1978.

Hochfield, Sylvia. "The Blue Print." *ARTnews,* June 2008.

Hoving, Thomas. "The Fate of the $5 Pollock." *Artnet,* November 6, 2008.

Hughes, Robert. *The Shock of the New.* New York: Alfred A. Knopf, 1981.

Jachec, Nancy. *The Philosophy and Politics of Abstract Expressionism.* New York: Cambridge University Press, 2000.

James, William. *The Letters of William James,* Volume 2. New York: Kraus Reprint Company, 1969.

————. *The Will to Believe and Other Essays in Popular Philosophy and Human Immortality* (reprint). New York: Dover Publications, 1956.

Jones, Amelia. *Body Art/Performing the Subject.* Minneapolis: University of Minnesota Press, 1998.

Jones-Smith, Katherine, and Harsh Matur. "Never Mind the Pollocks." *Nature,* December 2006.

Kandinsky, Wassily, translated by M. T. H. Sadler. *Concerning the Spiritual in Art* (reprint). New York: Dover, 1977.

Kaprow, Allan. "The Legacy of Jackson Pollock." *ARTnews,* October 1958.

Karmel, Pepe, ed. *Jackson Pollock: Interviews, Articles, and Reviews.* New York: Museum of Modern Art, 1998.

Kramer, Hilton. "Abstraction and Utopia." *New Criterion*, September 1997.

Landau, Ellen G. *Jackson Pollock.* New York: Harry N. Abrams, 1989.

———. *Lee Krasner: A Catalogue Raisonné.* New York: Harry N. Abrams, 1995.

Landau, Ellen G., and Claude Cernuschi, eds. *Pollock Matters.* Chestnut Hill, MA: McMullen Museum of Art, 2007.

Levin, Gail. *Lee Krasner: A Biography.* New York: William Morrow, 2011.

Limnander, Arnold. "Jack the Dripper." *New York Times*, March 9, 2008.

Maugham, W. Somerset. *The Moon and Sixpence.* London: William Heinemann, 1919.

Molyneux, John. "Expression of an Age." *Socialist Review*, April 1999.

Naifeh, Steven, and Gregory White Smith. *Jackson Pollock: An American Saga.* New York: Clarkson N. Potter, 1989.

Newcomb, Franc J., and Gladys A. Reichard. *Sandpaintings of the Navajo Shooting Chant.* New York: Dover, 1975.

O'Connor, Francis V. *Jackson Pollock.* New York: Museum of Modern Art, 1967.

O'Hara, Frank. *Jackson Pollock.* New York: Braziller, 1959.

O'Meally, Robert G., ed. *The Jazz Cadence of American Culture.* New York: Columbia University Press, 1998.

Ouelette, Jennifer. "Pollock's Fractals." *Discover*, November 2001.

Pater, Walter. *The Renaissance: Studies in Art and Poetry* (reprint). New York and Toronto: New American Library, 1959.

Potter, Jeffrey, ed. *To a Violent Grave: An Oral Biography of Jackson Pollock.* New York: G. P. Putnam's Sons, 1985.

Ratcliff, Carter. *The Fate of a Gesture: Jackson Pollock and Post-War American Art.* New York: Farrar, Straus and Giroux, 1996.

————. "Jackson Pollock and American Painting's Whitmanesque Episode," *Art in America*, February 1994, pp. 64–69.

Robertson, Bryan. *Jackson Pollock*. London: Thames and Hudson, 1960.

Rose, Barbara. *American Painting: The Twentieth Century*. New York: Rizzoli International Publications, 1977.

————, ed. *Pollock Painting*. New York: Agrinde, 1980.

Rosenberg, Harold. *The De-Definition of Art*. New York: Horizon, 1972.

————. *The Tradition of the New*. Cambridge, MA: DaCapo, 1994.

Rubenfeld, Florence. *Clement Greenberg: A Life*. New York: Scribner, 1997.

Saltz, Jerry. "The Tempest." *Village Voice*, September 12, 2006.

Sandler, Irving. *Abstract Expressionism and the American Experience: A Reevaluation*. Lenox, MA: Hard Press Editions (in association with Hudson Hills Press), 2009.

————. *A Sweeper-Up After Artists: A Memoir*. London: Thames and Hudson, 2004.

————. *The Triumph of American Painting*. New York: Harper and Row, 1976.

Schjeldahl, Peter. "American Abstract: Real Jackson Pollock." *New Yorker*, July 31, 2006.

Smith, Roberta. "Rivalry Played Out on Canvas and Page." *New York Times*, May 2, 2008.

Solomon, Deborah. *Jackson Pollock*. New York: Simon and Schuster, 1987.

Toibin, Colm. *Love in a Dark Time: Gay Lives from Wilde to Almodovar*. Sydney: Pan Macmillan, 2001.

Usborne, David. "Portrait of the Artist: The Life and Art of Jackson Pollock." *The Independent*, November 4, 2006.

Varnedoe, Kirk, with Pepe Karmel. *Jackson Pollock*. New York: Museum of Modern Art, 1998.

Varnedoe, Kirk, and Pepe Karmel, eds. *Jackson Pollock: New Approaches*. New York: Museum of Modern Art, 1999.

Wakefield, Dan. *New York in the Fifties*. New York: Houghton Mifflin, 1992 .

Wilkin, Karen. "Cezanne and Pissarro: A Crucial Friendship." *New Criterion*, September 2005.

Williams, Tennessee. *Memoirs*. Garden City, NY: Doubleday, 1975.

Wood, Paul, Francis Frascina, Jonathan Harris, and Charles Harrison. *Modernism in Dispute: Art Since the Forties*. New Haven and London: Yale University Press, 1993.

Index

Note: References to images appear in italics.